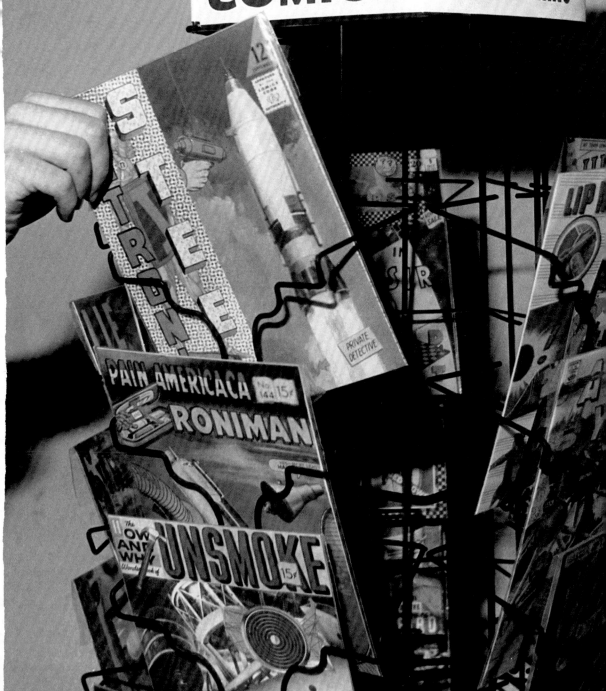

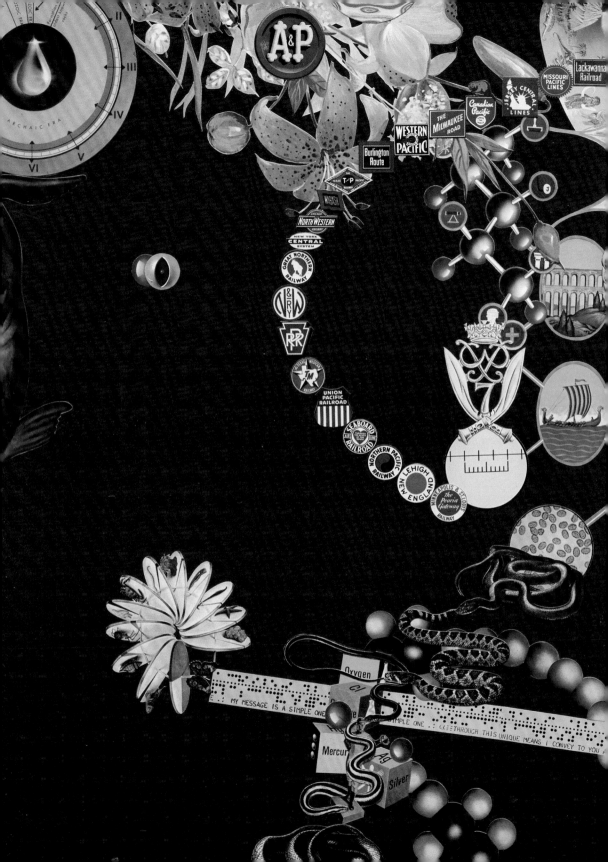

MICHAEL OATMAN

A LIFETIME OF SERVICE

AND A MILE OF THREAD

IAN BERRY

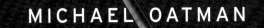

THE FRANCES YOUNG TANG TEACHING MUSEUM AND ART GALLERY

AT SKIDMORE COLLEGE

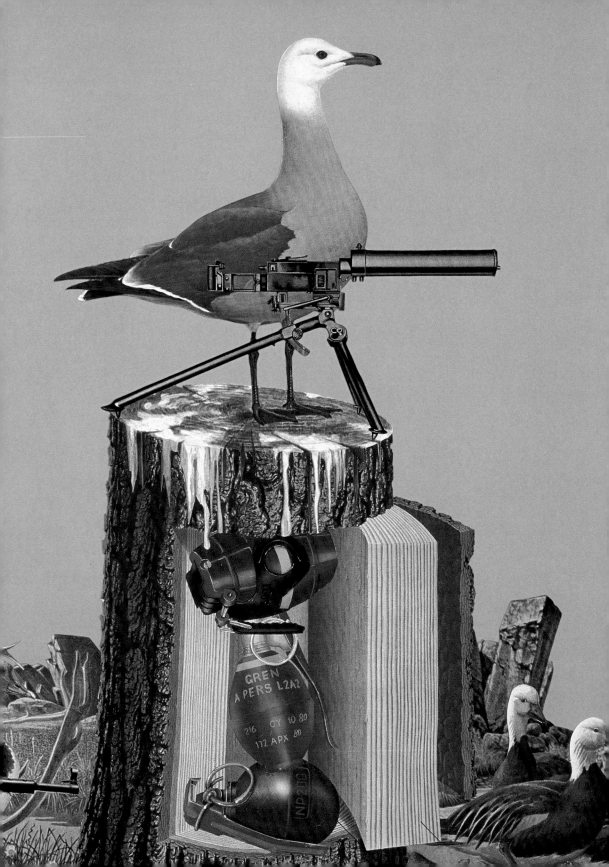

YOUR ACCOUNT OF YOUR LIFE IS UNRELIABLE

A Dialogue with MICHAEL OATMAN by Ian Berry

Michael Oatman listens to the dead. As he often says, he is a "dowser" in the tradition of those intuitive New Englanders who utilize unseen forces to locate buried metals, water sources, and missing persons. Oatman's searches unearth potent historical objects brimming with narrative intrigue and mystery. Fusing the roles of librarian, detective, taxonomist, and artist for twenty years, his practice invites us to see the world with curious and critical eyes. Autobiographical details, family tributes, and personal enthusiasms found throughout the work describe a world that is certainly his, but that also sets the stage for political statements, cultural warnings, and redemptive testimonies.

IAN BERRY: The earliest work in this exhibition is called *A Boy's History of the World in 26 Volumes* (1983). Did you make this when you were a student?

MICHAEL OATMAN: I made it during the summer after my freshman year at Rhode Island School of Design, when I produced one collage a day for a month. Originally the title was *A Boy's History of the World in 26 Volumes + 4*, but over the years some of them got damaged— well, actually one was stolen the first time they were exhibited, and then for the sake of likening it to the alphabet it was reduced to 26 volumes.

IB: You started with the form of a comic book page?

MO: I was looking for collage material like *National Geographic* magazines and encyclopedia sets, and I stumbled into a used comic book shop in Providence. There I found these plastic bags that collectors stored comics in and it seemed clear that I had to make some collages that size. In fact, up until recently I displayed the work on a rotating comic book rack in those little bags.

(facing page)
The Birds, 2002 (detail)
Collage on printed paper with welded steel predella frame
88 x 145"
Albany Institute of History and Art, Albany, New York
Albany Institute Purchase;
2003 Artists of the Mohawk-Hudson Region; 2003.14

(previous pages)
Code of Arms, 2004 (detail)
Collage on printed paper
106³/₄ x 54"
Courtesy of the artist

IB: Was that the first time you made a collage?

MO: I had made some a few years earlier in high school, as props for movies.

IB: Movies that you made?

MO: Yes, Super8 movies made with a friend, Mike Lawes. We needed to have magazines in certain scenes, but we didn't want to use, say, *TIME* magazine, so the letters would be mixed up to read "EMIT", or *Sphere*, a cooking magazine which was anagrammatized to spell "Herpes". In the background there would be people sitting around reading these vaguely familiar looking magazines, but they were remixes. At RISD my small collages eventually became studies for very large paintings.

IB: So when you started thinking about collage it was as a step towards making a painting?

MO: Right. I was doing a lot of experimentation. I was making mixed media drawings using found materials, I was exploring audio sampling, and making collage music on my Yamaha four-track, working solo and with various RISD/Brown University bands. I was using found film, which is a collage process. Many of these experiments ended up as paintings. Back then I believed painting was the most serious outcome an idea could have.

IB: When did collage become the end product in your process?

MO: I made collages on and off at RISD and a few years beyond that. Between 1984 and 1990 I produced a lot of collages as finished works, and by 1987 I wasn't bothering to translate them into paintings anymore.

IB: Looking at your past fifteen years of installations, sculptures, and videos, all of them are collages; all of them use layers of material put

together in an additive process. Would you describe your installations and sculptures as collages?

MO: I do describe them as collages with slight modifications to that term. For a long time I called my installations "maximum collages," "still films," or "un-vironments," because I was not happy with the term "installation." It seemed way too generic for my particularly narrative, autobiographical approach.

I never thought of my installation work as sculptural. To me it always seemed like it came right out of painting. I was setting up hundreds of still lifes that you would navigate by, like constellations, as you would move through this space, changing your point of view, seeing relationships emerge between things.

IB: Does site-specific fit into your vocabulary of describing your large-scale environments?

MO: I've stopped using the term site-specific for my work. Instead I think of it as "context-specific," because my works could manifest themselves in a very architectural way, they could be performances, or could be even more ephemeral. I think of all my installation projects as community-based, and that probably comes from having worked with my teachers Kate Ericson and Mel Ziegler. I was also part of a student team that helped Ana Mendieta realize one of her last works, *Furrows*, at the RISD Museum in 1984. That was an early cooperative project for me, as were performances with classmates Josh Pearson and Gardner Post, who would go on to form Emergency Broadcast Network.

IB: How do you get the material for your work?

MO: I have a very particular way of looking for things, and objects with significant histories come to me. It's not that I am finding them; they are finding me. It is my job to recognize them as mine and to interpret for the absent maker or user of that object. So I've come to think of myself as not exactly a medium, but somebody more like a

Understudy, 1991
Xerox text on tracing paper
in the form of a men's size
40 suit pattern, varnish,
iron hook, clothes hanger
Installation dimensions
variable
Collection of the artist

dowser. Things come to me by intuitively reading the moment, provoking chance a little bit, and I end up finding something I wasn't looking for.

I will, in some sense, role play in order to find things, like one of my media heroes, Jim Rockford of *The Rockford Files*. I sometimes step outside myself in order to gain access to objects or information. I slip into dialects, becoming a different person, and in a way I think the transformation that I have to undergo is something that I wish for my viewers.

IB: Do you engage in research during this process?

MO: Most of my work involves research. I spend a lot of time in archives and libraries, or conducting interviews, but much of it is spent among things made by people who have long since passed away. I'm interested in how the lives of those makers affect the meaning of the things they made. And I am not just talking about art works, but also manufactured goods or things made by hobbyists, even the personalization of living space that everyone does.

In 1991, I started looking back to the real inspirations for my work. As a kid I read detective stories, and I was especially engaged by the crime scene diagrams—you know, strange, not even axonometric, but weirder perspectives on rooms, kind of looking down and sideways at a space. Here I was, building these narrative machines, where I really wanted viewers to touch things—much to the dismay of curators—and I realized that I was asking a lot of the viewer, to function like a forensic police officer coming into a crime scene.

Around that time I found some books by Dennis Wheatley called the *Crimefiles Series*. They were published in the 1930s, and were incredibly

popular. They were the ultimate "police procedurals" because they presented the story in the nonlinear form of a detective's dossier—fingerprint sheets, telegrams on the right paper, even actual human hair and cigarette butts editioned in tiny cellophane bags. This is what I want to do with my installations, to give people the real stuff, and let them mess around with it and make decisions about where to go, like in a video game or the CD-ROM novel, MYST.

IB: The reader not only figures out the story, but becomes a character in the story.

MO: I am hoping that my viewers will do the same—be active viewers, make some decisions, and create situations where sometimes they can actually affect the outcome of a history by their presence in a space.

IB: But these works are very autobiographical, or at least components of your story are fueling your works. Do you want us to know that or is that just for you? When you insert something of Vermont, or your family, or your self-portrait, or a memory of a dream, how much of that is for your pleasure and how much would you like us to discover?

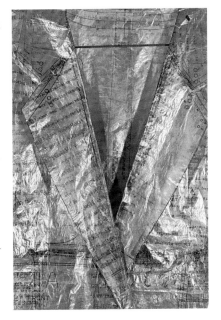

MO: The story I am telling over and over again is about going out into the world, finding things, meeting people, and dreaming of other histories. It's not the only story, but part of what motivates me is the thrill of discovery. By pointing viewers down the path of my original discovery, our lives come together for a moment.

Once, a musician friend asked what I was trying to accomplish with my installations. Without even thinking I said, "I'm trying to make the visual equivalent of the Beatles' *A Day in the Life*." To me, that's a perfect artwork—John pulled stuff from real news headlines, and basically sings a song about process.

It tells the story of its own creation. Then Paul comes in and talks about how his day starts. It ends with him going into a dream. Together, they reveal the micro and the macro. Not to mention the fact that every aspect of the music, from the recording to the collage of found sound, was shockingly new.

Two basic components are always present in each work. First, there is the story about me finding the thing, and sharing this story with viewers. I am the agent of its salvage. Second, a lot of these things come from an earlier era, and their orphaned quality draws me to them. These stories and objects have lost their meaning in contemporary culture, and this really resonates with all stories of loss, both culturally and in terms of nature. You can think of it as a natural selection of ordinary objects, the survival of the most utilitarian, the most convenient, the most meaningful. Things have an incredible resonance partly because they have disappeared.

Whether I present what I find as fiction or fact doesn't really matter. I'm dragging you through this thing physically, placing you in front of an image. Then the ball is in your court.

IB: What is an example of a work that told your story overtly?

MO: A 1991 piece entitled *Understudy* is a men's size-40 suit made from two tracing-paper suit patterns. Before I cut the patterns out, I copied my autobiography onto the tracing paper using a large format Xerox machine. The text went from my earliest memory as a child to age seventeen, when I left home for college—really just a list with a lot of holes. I wore the suit only once, with nothing on underneath it, as part of a performance piece, and then it simply lived on a wire hanger and hook, the pants and the jacket, as a sculpture.

An understudy is someone in the theater who learns a role in hopes of going on, in case the lead has an accident or loses his or her voice. For me *Understudy* became a talisman, and let me leave behind the paintings I had been making. It was my cue to engage with a new way of being an artist.

IB: In what other ways have you made your self-portrait?

MO: In the spring of 1991 I went to the Troy Police Department and I filed a report. I had been assaulted, and I described my attacker to the detective who worked with the Identikit, a series of transparencies with facial features. About two hours into this interview the detective looks at me and says, "Is this you?" And I said, "Yeah, but I talked to the police chief and I cleared it for this art project." I later used my separate facial features as the pattern for bed sheets in the 1992 installation, *Immortality Rate.*

What I found fascinating about this process was that he was making a drawing by using an institutional questionnaire, because there is a specific order in which questions are asked and then re-asked to determine if you are lying. At a certain point he knew that my story was being made up. Relying on another person's creative interpretation inspired me to make a whole series of self-portraits in a really roundabout way. Since then I have commissioned other self-portraits including a song, a tiny game piece carving of me looking through binoculars and my own obituary. I met the *New York Times*' advance obituary writer, a man my age, who, for instance, has been working on Saddam Hussein's obituary for twenty years. Our deal is that if I predecease him my obituary comes out as a self-portrait, but if he pre-deceases me, then the artwork doesn't get made.

IB: How have you created characters for your projects?

MO: From many sources, both real and fictional. *Michael Oatman Presents Robert MacKintosh: The Responsibilities of Disappearance* (1994) was a retrospective of one of my RISD teachers, a Scottish ex-pat, who came to America in the 1920s. His work anticipated every major movement of twentieth century art, from Surrealism through AbEx and Minimalism, up until he disappeared for the third and final time in the 1980s, after he was my teacher. He's been stepped over by historians, but was very influential in the New York art scene of the 1950s. So I gathered up MacKintosh's paintings, drawings, sculptures, and commercial illustrations, everything I could find. I found photographic evidence of his life from friends and family, and basically did a big curatorial project presenting sixty years of his work.

What I didn't tell anybody was that MacKintosh doesn't exist, and that I had been making art under his name since about 1983, along with a classmate from RISD, Brian Kane. I wanted to write into existence a person much in the way that a novelist might, except that instead of doing it with words, I used the physical—but fictional—evidence of his life. I "found" an 8mm documentary film showing MacKintosh in 1954. I actually filmed it at Dempsey's Bar in Troy, New York, using local artists as characters who might have populated the 1950s New York art scene. Friend and carpenter Tom Blodgett made an appearance as MacKintosh, and he even made a painting—in three minutes!—on camera.

As I was editing the film I realized that I wasn't making a piece about Robert MacKintosh, but about myself, about the problem of failure, of not making it as an artist. I was showcasing my own anxiety about being an artist, about getting out of school and being on my own.

IB: You have since employed the combined role of artist/curator, as when you were invited to make a work for the Fleming Museum in Burlington, Vermont.

MO: That invitation came from Janie Cohen, the Fleming's curator, who had seen the MacKintosh exhibition. I spent six months looking at literally everything in the collection—some eighteen thousand objects: paintings, stamps, armaments, coins, sculptures, scientific equipment—and I couldn't come up with a theme for the show. It was very distressing because time was marching on; we had only six months before we had to open. Finally, out of desperation, I began to research the museum's history. I learned that the first director, Henry Perkins, was not only a teacher in the University of Vermont's biology department, but also a eugenicist. That was a word I remembered from Holocaust studies in high school. I wasn't really sure what it meant, but I began to investigate it. I learned that Charles Darwin's cousin, Francis Galton, decided that society could be improved by selective breeding. Sterilization ultimately became the best way to manage potential offspring from "undesirable unions."

It turns out that in the mid-1920s Perkins was looking for a high-profile project for his graduate students. They conducted a survey of four thousand Vermonters to find the "pockets of degeneracy" in the state—in the language of the time—the pinheads, the feeble-minded. Where were the alcoholics, where were the cases of incest? Through his Eugenics Survey of Vermont he lobbied the state legislature to pass sterilization laws that would allow any three doctors who concurred—upon obtaining the signature of the patient—to sterilize that person for the well-being of Vermont's genetic future.

When I uncovered this incredible story behind the first director of the Fleming, I knew this project was no longer a straight curatorial intervention. Janie Cohen very bravely went along with every request I made, like not having cases or labels. I used the collection as a prop room, and in the end incorporated over one hundred objects from the Fleming, many acquired during Perkins's tenure. The other things I made, commissioned, or found, including, amazingly, a missing trove of Eugenics Survey paraphernalia in the attic of my high school.

My tenth grade biology teacher, David Ely, was the UVM student of Paul Moody, who was the UVM student of Henry Perkins. Perkins's "Race and Heredity" course at UVM, which was taught long after his death, into the early 1960s, was finally cancelled because of its racist content. All of the material—lantern slides, textbooks and even a series of wall charts—were jettisoned in a fit of embarrassment and wound up in my high school. I incorporated these artifacts into my installation *Long Shadows: Henry Perkins and the Eugenics Survey of Vermont* (1995).

IB: How strange was it to find that this happened near where you were raised?

MO: It was shocking to learn that American eugenics practices were studied by the Nazis, guiding the master plan for the concentration camps. But in order to make *Long Shadows*, I had to see Perkins in fairly gray terms. He was a product of his time. His mission was seen by many as a noble one, up until 1936, when it was revealed that Hitler had used American eugenics methods to sterilize fifty thousand

people. Perkins was a racist and a zealot, and went to his grave defending eugenics. But he was also a husband and father, a birdwatcher, a radio personality, a woodworker. He maintained a handprint collection of his family, students, and friends. He died from alcoholism, one of the traits he was trying to breed out of the population.

IB: How did you relate to the racism you were presenting?

MO: As a white man growing up in the whitest state in the country, I felt that Perkins had shaped me, as surely as he tried to cleanse the countryside of bumpkins and gypsies. In order to make this piece, I had to get my head around issues of race and destiny that I was confronting for the first time. I had to step into his skin. It was actually mortifying. Alfred Hitchcock had it right: the guy next door is the most terrifying, because he seems so nice, so normal. Instead of wielding an axe to eliminate people, Perkins used the Vermont legislature. But, it was necessary to learn about his life, his passions, and his family. I began to identify with him, and I don't think the piece would have been as powerful if I had merely vilified him, dehuman-

(this page and facing)
Immortality Rate, 1992
Mixed media installation
400 square feet
Installation view, University
at Albany, Albany, New York,
1992

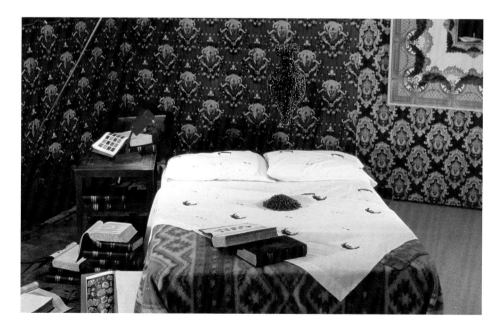

ized him. In 2000, working on a re-install of *Long Shadows* for MASS MoCA, I caught the bug again, and was looking for eugenics-related stuff. In a Burlington bookstore, on a dusty top shelf, I found a copy of *Rural Vermont*, the first product of Perkins's Vermont Commission on Country Life. It turned out to be his personal, autographed copy.

IB: You use words that allude to something criminal in your actions as an artist. What do you gain from creating an alter ego that can commit crimes or finding an outrageous historical figure to inhabit for a while?

MO: Alter egos have been present in my work for a long time, since about 1983, when I learned about Duchamp's female persona, Rrose Selavy. The idea of "stunt-doubles" was very liberating because here I was making things that had real materiality and gesture, and in one way I was completely sincere about them and in another way they were lies. Yet they were completely concrete, it wasn't like I just invented something out of thin air. They presented evidence of a life, even though that person didn't exist. So when I did the MacKintosh exhibition I felt I was writing a life into being, I was forging the artifacts of a life spent making art, telling how he periodically disappeared, returned to the scene, caught up with friends and then disappeared again. I don't think I could have made those experiments as Michael Oatman; it wouldn't have been seen as genuine.

The work of a few artists that I was starting to see for the first time—Cindy Sherman, David Hammons, Ilya Kabakov, Lorna Simpson—hit me hard because of the homogeneity of the place I grew up in. Because of the political climate of the early 1980s, I felt that the most incidental part of my story, being a white, American male, maybe wasn't a valid story. It was, after all, the dominant story. I began to see crime, my own criminal history, as something I owned, something that I could explore.

IB: What do you gain from a lie, what do you gain from a transgression? You are telling the audience something that isn't true, which could be a crime, but what else is criminal about what you do?

MO: Maybe "criminal" is a strong word. I think artists have to be free to take from the world of ideas what they want—you have to give yourself permission to think thoughts that people normally aren't able to think, without being reprimanded or imprisoned. To willfully want to be seen as different is saying, "I will be an artist," and that is not very comfortable for many of us who would rather blend in, have the work do all of our talking. I think what I gained from creating alter egos and from breaking rules was not so much a material gain or a gain in power, but access to the kinds of freedom that my teachers were telling me about, a freedom that I actually had to go out and take. You had to be brave in order to understand what it meant to have an idea that was a personal risk in the world at large, different from a risk within the art world.

IB: Much of the best artwork of the past two decades has come from very personal sources. I am thinking about Robert Gober, Fred Wilson, Nayland Blake, Kiki Smith, Jim Hodges, Matthew Barney, for example. Work about their own bodies, maybe activist in some way, but very personal. Where do you draw the line between what is private and what is public for viewers?

MO: I cannot remember a time in my life when I haven't felt embarrassed. About issues of class; about really loving sports, but not being a natural athlete; being identified as a gifted artist as a young person, and getting to RISD and feeling like a fraud; about being a big guy in a skinny art world. Making things helps build a wall of defense against being discovered as a fraud, or not really being as good an artist as you think you are, or as people think you might be. These things for me have come out of what I thought for a long time was a Rockwellian kind of childhood, where I told myself I had a great relationship with my parents, which I do now, and that I engaged in very little, if any, of the rebellion that kids go through. I woke up as an artist at one point, and realized that those stories I had told myself were as much constructions as the works I was making.

I had a great childhood, but stitching in and out of it was my Mom's very difficult battle with mental illness. It affected how I saw

myself, and probably how my brother saw himself. In fact, Tom and I called our parents by their first names, and our friends couldn't understand that. I think it was a way to acknowledge that Gordy and Shirley were also individuals, with their own private thoughts. It was about seeing Mom and Dad as real people, the way friends are different from family.

I have come to understand that a lot of the work that I have made has really been about my instinctual distrust of institutions, of organizations that are health-related, specifically in reference to my Mom's difficulties. It's about being a young person visiting her in the hospital when she was very ill, and not really understanding what was going on, and taking away from those visits incredible sense-memories of the colors, the equipment, the way people behaved, the scale of the spaces, the quality of the light, the sounds, the textures of things. Institutional forms play a big role in my work

My interest in architecture and design from the 1920s through the late 1960s is informed by those very confusing moments of encountering monolithic bureaucracies like hospitals, or the Boy Scouts (I was a Life Scout), or state government, even something like what happens with a high school marching band, the structure, the set of rules, the equipment, the formats. I always found myself operating both outside the rules and as a kind of impresario within those situations to cover for the fact that I wasn't really as skilled at it as everybody else was. I am often looking for the memories that are the most frightening, because if you are manufacturing fear, then it feels like you have control over it, which is probably the truth.

IB: If you get to wear a costume or a mask, then it is not really you that is going to get hurt, it is the character.

MO: Right, and it has been very useful to have these kind of characters in the work, even people that aren't fictional, a Henry Perkins, or an Andress Hall, or MacKintosh, excuse me, MacKintosh *is* a fictional creation. Imagining myself as him worked like an alias, a way to take some of the heat off the really most emotionally difficult passages in my own story.

IB: How do you determine if one of your pieces is successful or not?

MO: If I can encounter it in a way where I don't really remember making it or if it seems strange to me then I know it is right. This is going to sound contradictory, but I don't ever consider the piece to be dependent on the viewer's reaction. However, I think of my viewers when I am making a work in the sense that I like to explore the ways in which someone might encounter it. I always build into the installations something that happens below the three-foot mark to address children and people who are mobility impaired. So I think a lot about the audience up to the point of their reaction, but it doesn't really matter to me after that.

IB: It doesn't? I am surprised. I think that you spend more energy than most artists thinking about or working on collaboration, working on dialogue, working on recording and...

MO: But let's not mix up my role and the role of the viewer in what could be many different kinds of dialogue. Some of the worst things I have made have been an appeal to an audience where I wanted a specific kind of reaction so badly that I was destined to not get it.

 I very much doubt that I am one of those artists that would make things without the potential for dialogue between people. I found that the act of being out in public, of gathering objects and information and meeting people was very exciting and the work was enriched by it. There is only one period of time in my life as a painter when I think I was really in the groove of making things. I was making strong images and I had found a process, some ways of working that I thought were my own. Painters, you know, many of them say they find themselves in the studio working in isolation. But going outside was how I got to have that experience. It was like trying to be isolated in public.

IB: We just walked through the Fairbanks Museum in St. Johnsbury, Vermont. As we were walking around you remembered coming to this museum on school visits as a child and then continuing to come as you grew. I certainly see a lot of your influences in those displays.

MO: I am constantly referring back to these wildlife display strategies. I find that they are not really static displays, I mean there are technical things that you discover about how they did it that seem completely fresh. You see it in the dioramas that show cross sections in the ground and seeing plant roots in the dirt, pressed against the glass display cases. I once saw an exhibit there about objects that had been lowered to the ocean floor in a bathysphere. A Styrofoam cup had been uniformly crushed to half its normal size. On the other hand, there were the bug pictures made by John Hampson, one of which is part of *Iceberg*. There were always displays of both the marvelous and the mundane. What made it work was the context.

IB: This museum inspired your sense of discovery and wonder in addition to the visual look of the place.

MO: Oh, yeah. At a very early age, probably influenced by these trips, I began to arrange things in my own room, my airplane collection, my rock collection, my books. I remember asking my dad for a wooden box that he had made for his fly tying equipment. He was making these things to sell—it was made out of cherry, and he went through a couple of prototypes before he got to the best design—so I asked for one of those to house my mineral collection. Later, I would display my beer can collections on the wall. The experiences that informed the rigorous way that I ended up categorizing the things in my room were my visits to the Fairbanks and the Perkins Geology Museum at UVM. These were places that had so much stuff on display at any one time that there was a density that just felt right, and so my own room at home echoed that.

IB: Do you think your work, collages and walk-in environments in particular, are all versions of this?

MO: This type of work has a tendency to take over. It's a little strange to live in a cabinet of curiosities, but that's what it has become, if not a museum. So my home starts to look like my work, and I feel like I could plop right down in one of my installations and watch TV. Which, in fact, is how I go about culling collage images.

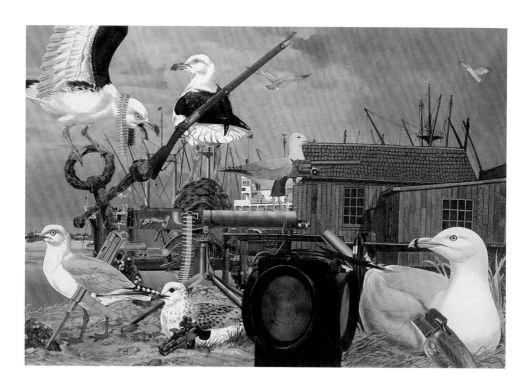

When I start to cut pictures out they get mixed in with other pictures and things begin to happen. It's the mixing that puts them back into the world for me, because it is not a neat world, biology is not separate from chemistry, history is not separate from how the weather works, so in cutting pictures out of books I get to take them out of captivity and put them back into the wild.

IB: Interdisciplinary work for you is a given. What are some of the experiences that pushed you in that direction?

MO: I think about my grandfather, who had over three hundred clocks; I look at my grandmother, who had a collection of these cheesy but interesting Toby mugs. It was a very thorough collection of hundreds of portrait mugs isolated on one massive shelf. The clocks, on the other hand, were distributed throughout the house and basement, and he wound a hundred of them every day. It was a relentlessly ticking environment. That left a big impression on me, both in terms of an environmental condition and a daily process,

Study for The Birds III, 2003
Collage on paper
21 x 27"
Location unknown

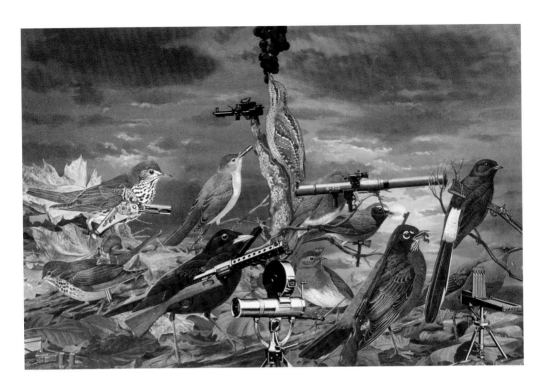

a ritual. The mugs were about taxonomy and order, the clocks just dominated everything.

My dad was—and is—a voracious reader; my mom gardened. He worked in the wood shop, she sewed upstairs, and together they "arrived at" projects for the home where they each had some sort of say in the design, and often materially collaborated on the physical output of some modification, like window boxes or a kitchen renovation. I've collaborated with them on a few occasions, and hope to do so with my brother Tom. We both sewed, but Tom got really good at it, and made practical things like gaiters for skiing, or modifications to his clothing. There was actually an intense atmosphere of making in our home, whether canning produce, carving furniture or building model rockets. We practiced traditional handicrafts, not art.

My approach to technology is sort of sideways, partly because I think there are old ways of doing things that still have validity, still have a craft to them that I haven't mastered or figured out yet, and it is almost like I want to spend time with those things before I move on to the latest and greatest.

Study for The Birds I, 2001
Collage on paper
23 x 29"
Collection of the artist

IB: Fred Wilson was an important influence on you as an artist. Could you reflect on the first time you found out about his work?

MO: Fred is an artist whose work has become very important to me, even though before I had ever heard of him, we were working in very similar veins. In 1993, I made an installation called *Michael Oatman's Menagerie*, which looked at colonialism using animals as metaphors for human populations, and specifically looked critically at the history of museums and zoos, cultural institutions that we all revere. Shortly after that I learned of his project with Lisa Corrin, *Mining the Museum*. We both had our versions of, in the parlance of Andy Warhol, "raiding the icebox."

Through *Menagerie* I realized that the formal, cultural influences on my work actually came straight out of these colonial practices of looting artifacts and enslaving people. My beloved dioramas and vitrines were nothing more than prisons, filled with things that had been seized by foreign museums during expeditions funded by foreign governments. So my piece, which was looking critically at the things I loved, led me to a greater understanding of my own cultural heritage and responsibilities.

IB: Fred is an artist who also goes into a situation and finds a history and uses things that already exist in that place.

MO: Fred has given us the term "mining," which I think is a great term. I have used the word "dowsing" over the years, which is perhaps less focused and less double-edged than what Fred does. I am hoping to stumble across things that are not necessarily driven by the same issues that drive him. I am trying to leave myself open to whatever I find.

IB: Not narratives that are on the surface, but what we keep hidden, the things that have secretly shaped us.

MO: The new piece, *Iceberg*, is about secrets, but it also talks specifically to my teachers, some of whom are now peers. *Iceberg* is that mirror

that I was talking about earlier, about recognizing that there was something in art that could sustain me if I was willing to meet it halfway.

IB: When you were first thinking about making a piece like *Iceberg*, it was partly a project for dealing with the constraints of a certain space. I'm also interested in how you came to the idea of an alphabet of influence. Why make visible the part of your life that is usually hidden?

MO: Re-seeing the Wachenheim Gallery at the Tang, it didn't feel like I had any constraints, and it was a little overwhelming to be given such a big room and so many spaces around the museum to deal with. That's not something normally available to me when I do a project, and I usually have to do a lot of retrofitting in order to make something work. So as I began to think about the physical spaces of the Tang I also considered the ephemeral material of my life. I needed a way to organize my influences, and alphabets are elemental.

My questions began with this: how does someone decide to be an artist? Does it just happen? What was my version of that? It meant looking hard at various periods of my own evolution and asking, "Did something important happen here? Did I have a setback there? Where did I have doubts about this enterprise?" By choosing to merge the attic and the basement, areas of a house that are usually off-limits to strangers, even friends, I was letting people explore some very messy territory.

IB: So it was about looking retrospectively?

MO: Yes, and it was not a very graceful reckoning. Even though I felt a lot of excitement uncovering older ideas, some that maybe have yet to be realized, I had a lot of apprehension about whether or not making art was something that I should continue to do. I was looking at the trade-offs of spending twenty years as an artist, spending forty years being in relationships and friendships, seeing how these two things affected each other, and I felt the show called for a new piece that would function like a high-powered lens. There were all these lenses

Long Shadows: Henry Perkins and The Eugenics Survey of Vermont (Vermont Pure),
1995/2000
Installation with video, painting, sound, text, objects from the Fleming Museum
Installation views, MASS MoCA, North Adams, Massachusetts, 2000

that I had been using—my job, the end of my marriage, the loss of my studio—some were dirty and others were crystal clear. I felt that a new piece paying homage to the people and ideas that had influenced me, really, would help me see all the stuff on the other side of a very high wall.

Finally there was this architectural problem of the gallery, that big twenty-foot wide entryway, and I decided that was exactly what I would address in this show—fill a gaping hole personally, patch something up in order to find out what these works taken together amounted to.

In 1986 a friend gave me Paul Auster's *New York Trilogy*, and his story "The Locked Room" has become, for me, the most important book of the trio. It concerns Fanshawe, a writer, who dies, and in his

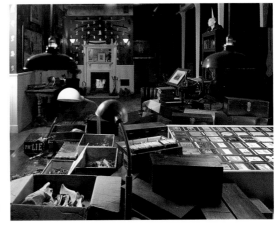

will he instructs his widow to contact another writer, a boyhood friend. That friend goes to Fanshawe's house and looks at all of the work that he has been doing in secret since they were boys: essays, novels, poems. The will further asks the childhood friend to determine whether the work is any good, and to destroy it. The man realizes that Fanshawe was one of the greatest writers of his generation. He packs it all up and puts it into two suitcases and walks down the stairs, and he remarks to himself that together all of the works equal the weight of a man.

Maybe I thought that these works by my teachers, friends, and parents would equal me. *Iceberg* was a way of looking at my life both directly and askance. I had to go into my own darkness with that installation—it is physically challenging to move through—in order to bring myself through the other side to this stuff that I was making, the "art."

Because of how I was feeling about the work, about some big transitional moments in my life, it is not a show that could have been made without the kind of dialogue that we have had, Ian. There were times when I really needed another way of seeing.

IB: That is one the best uses of having an exhibition. Certainly for an artist and definitely for a curator and an audience, we can see works that we might think we are familiar with in very different ways.

MO: I think it is very important for artists—it has been important for me —to develop confidence, but in some ways to develop a critical lack of confidence, if that doesn't sound too much like double-speak. To find these vulnerabilities and expose them to the air, you know, keeps things moving forward. I have become very skeptical of some of my working methods. Others have persisted. Maybe that's why collage re-entered my practice.

IB: I remember the very minute I saw *Anaximander*. I couldn't stop looking at it. It was like a tractor beam for me. What went into making that first oversized collage? Did the material guide you, did you start with this size of paper and say I am going to fill this, or did you start with a form?

MO: The first thing to emerge in *Anaximander* was the idea of a massive tree. Again, this came from just cutting out material. I was going through my books and cutting out discrete animals, culling them from evolutionary trees, made out of oversized arrows. But I couldn't figure out a way to use the arrows, they just got in the way. So I was taking discrete animals out of those paths and then I think I cut out one in its entirety, because I liked the shape or the 3-D quality of it. And of course, as soon as I got it off the page and tacked it to the studio wall it looked like the branch of a tree, and I thought, "I will make a tree out of evolutionary tree branches." Very quickly I got the idea of placing it in a Vermont landscape and then from there it was a short step to hybridizing evolutionary theory and creation stories, so I made an Edenic version of my home.

IB: Utopian?

MO: Utopian, yes, but specifically paradise—the Garden of Eden meets my backyard. It also references eugenics, which I still think about a lot. There's a tree with a dragon wrapped around it, in a lush landscape, and the only human in the picture is Charles Darwin, sitting in a chair at the very top. I was reading some science history and discovered the ideas of Anaximander, the pre-Socratic philosopher, who is credited now with so many inventions—maybe even the beginning of the scientific method. Here was someone who was wrestling with origin stories, wondering about the materiality of the world, how it came about, and his theories were, I felt, an intersection of the divine and the phenomenological, of desire and of the observed. He was the ideal persona to organize my own ideas around.

 Anaximander is a complex picture, and in making it I began to see that the time spent, the research involved and the depth of information

was analogous to everything that went into making my installations. Could I make a two-dimensional installation? Because it was the first really big collage I wanted to make, I was up for that challenge. I wanted to get in over my head in terms of working with color again, in terms of the amount of imagery. I wanted something overloaded.

IB: How did you end up designing a frame with images?

MO: Well, I felt in the end only two things were happening in the main body of the picture: this tree with a very complex organization of parts and the landscape. It was a classic figure/ground composition, and I felt that I was putting so much into seamlessly knitting together this landscape that there really wasn't any room for the kinds of cultural components that I wanted to include. Landscape is a cultural construction, I know, but I used to have a relationship to it that was pretty raw, animalian. Tom and I spent more time outside than inside as kids.

There were cultural artifacts like the satellite dish and the dragon, and even the bower birds, which are the only animals that we know of that seem to have a sophisticated aesthetic sense. They gather things, they organize them by type, as part of a courting ritual, a mating ritual. We have assigned them human qualities. There was a reference to the cave of St. Francis, specifically my favorite painting, Bellini's *Saint Francis in Ecstasy*, but only a few moments in that collage really spoke to history or technology. I wanted to set up a dialogue between the densities of that landscape and the density of ideas in the world, so I did that band on the outside. I thought of it almost like a pro-wrestling belt of images, or jewelry for the piece.

IB: All of the history of life.

MO: Right. In some ways it is a warm-up for this cosmological piece that I have been working on for years. I want to make a collage, one picture that has all the information of an encyclopedia, in the way that we can now have twenty-six volumes of information on one CD-ROM.

IB: So what is that going to be?

MO: I imagine that the collage will be quite large and it will be a landscape that you can read temporally, up and down, left to right, and front to back.

IB: Front to back?

MO: Yes. Things in close proximity to you are from an earlier time, things further away are later in time. Maybe the reverse of that. But the idea is to really go through all these books and pull out discrete histories, you know, the periodic table, the history of flight, building typologies over time, and to put them together in perspectively correct space where the way you read the image unfolds it in time, so...

IB: Like a Chinese scroll.

MO: Yes, or like my second favorite painting, the Rubin Museum's Tibetan tangka in *Iceberg*.

IB: But with deep perspective.

MO: Imagine hundreds of different trees that make up the landscape in the background, each of them identifiable by their leaf type. The cross section of the earth in front of us would have various layers of history. The best example I can give is a road that curves into the distance. It would start in the foreground with rather large rocks and minerals, and I would use smaller versions of those as we went back into space, but each one would be different, all capable of being identified with a key. On a website, a pass of the mouse over a discrete element of a picture might reveal a title, like "Order Hymenoptera" or the "S-51 Sikorsky." So I would like to make that epic landscape function as a very big, very inclusive manual for the planet, like a time capsule or the data on board the Pioneer 10 spacecraft. I don't think this is all that different a project than Bruegel's proverb paintings or what Bosch did with *The Garden of Earthly Delights*. They were

Back cover illustration of book
Alfred Hitchcock's Rope,
Dell, 1948
Collection of the artist

presenting different idiomatic expressions, or cataloging sins or identifying plant types. They were meta-pictures.

IB: It will be interesting to see what happens!

MO: Well I think that particular collage might be the end run of this idea that I have about the collages being 2-D installations— the ultimate image. Maybe I won't want to produce any more pictures after that. Luckily, it will take a long time to make.

1.The title of this interview is taken from the John Jannone/Michael Oatman video, *Tale of the Middleman (gauging mercy)*, 1991.

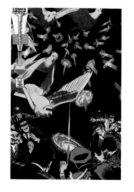

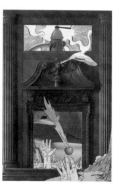

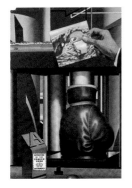
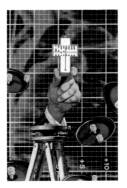
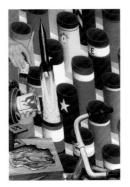
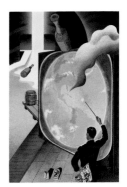

(this page and facing, details on overleaf)
A Boy's History of the World in 26 Volumes, 1983
Twenty-six collages on paper
Each approximately 10 x 7"
Courtesy of the artist

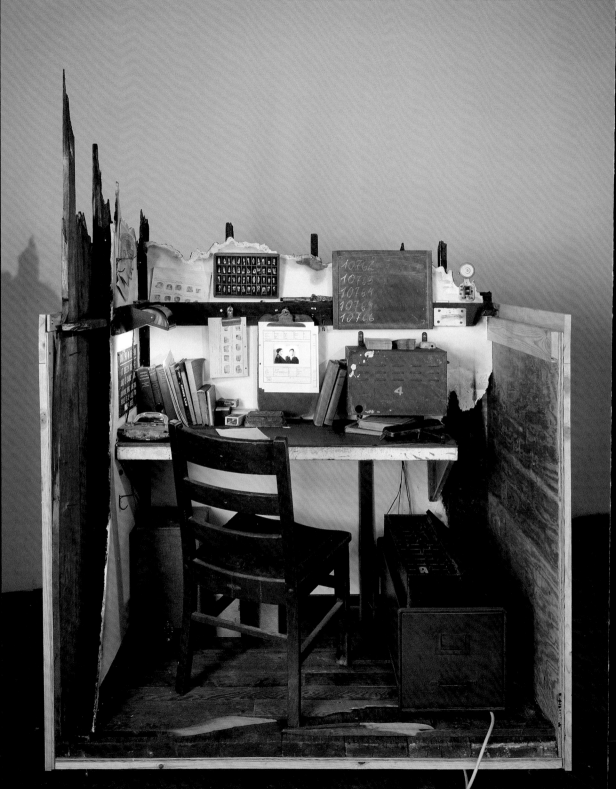

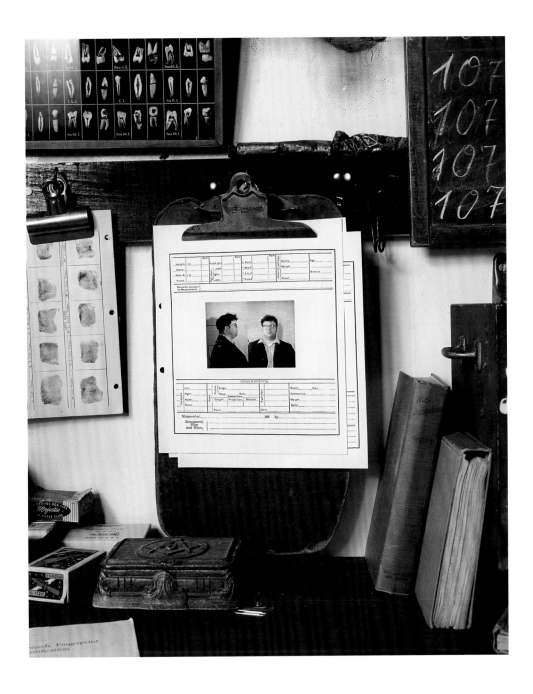

(facing with detail above)
Taken: 1° The Photograph, 2° The Confession (traveling version), 2001
Mixed media with video
61 x 38 1/2 x 54", 81:17 minute video
Courtesy of the artist

The artist recounts his own criminal history and proximity to criminal events in a performance filmed with two cameras. The recording was edited to simulate the frontal and profile views of a traditional mug shot and installed within a fantasy police crime lab.

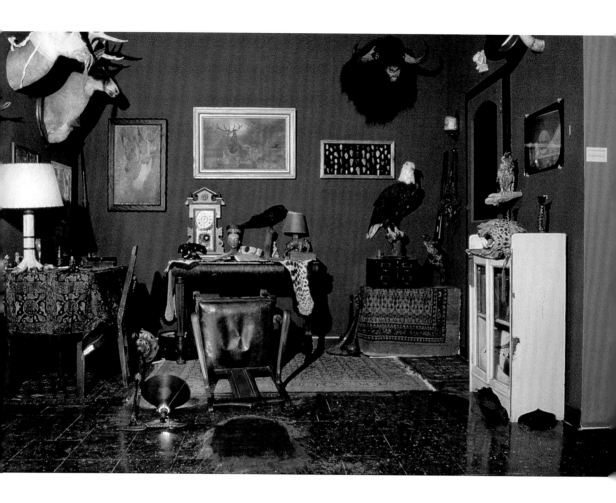

Menagerie, 1994 (details)
Installation with video, painting, scent,
and collections of taxidermy, African
artifacts, live insects, and weaponry
500 square feet
Installation views, Schacht Fine Arts
Center, Russell Sage College Gallery,
Troy, New York, 1994

Fusing strategies of natural history museum displays
and responses to the 1991 Rodney King beating in
Los Angeles, *Menagerie* imagines the collections of an
unidentified late-nineteenth century white curator/
zookeeper to explore Oatman's own relationship to
colonialism, fetishism, collecting, and the museum.

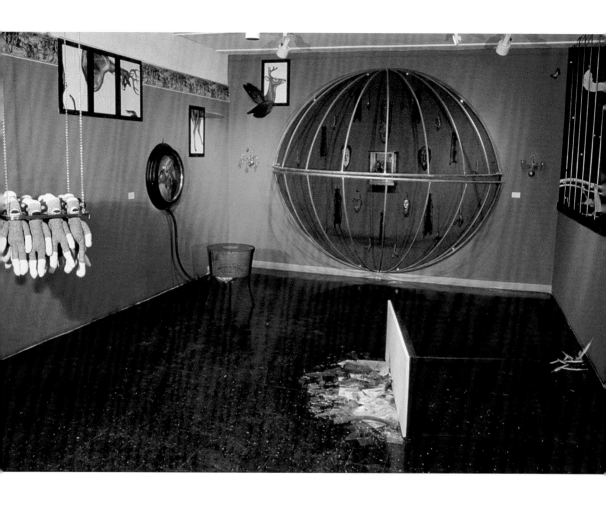

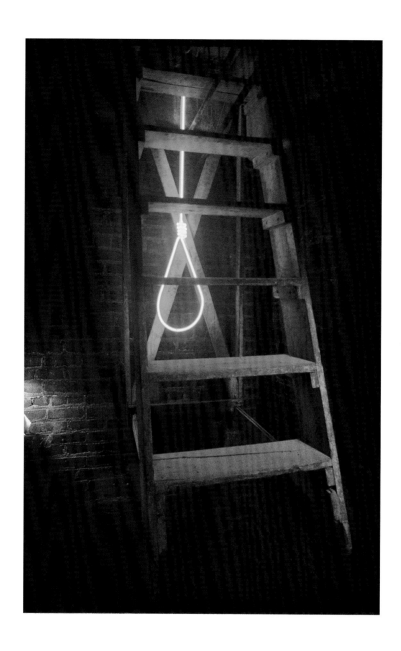

(this page and facing)
Awful Disclosures: The Life and Confessions of Andress Hall, 1995 (details)
Installation with video, sod, embroidery, custom cutlery, stenciling, neon
144 square feet
Installation views, *Hidden Histories*, Albany Center Galleries, Albany, New York, 1995

Andress Hall (1824–1849) was a semi-literate drifter who by age 24 had committed numerous thefts and several murders around Troy, New York. Before his hanging he confessed his actions to Baptist Rev. George Baldwin. Oatman's installation, based on key events in Hall's life, was presented in the working boiler room of the gallery and featured a false floor, pitched at 11 degrees and covered with sod, a neon noose, and a theatrical reading of Baldwin's text played on a tiny video monitor.

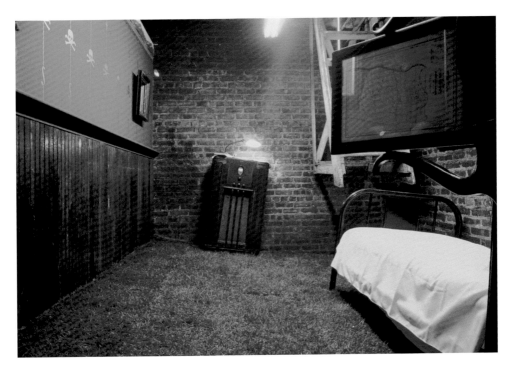

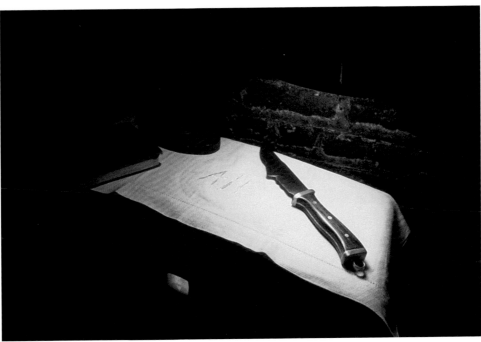

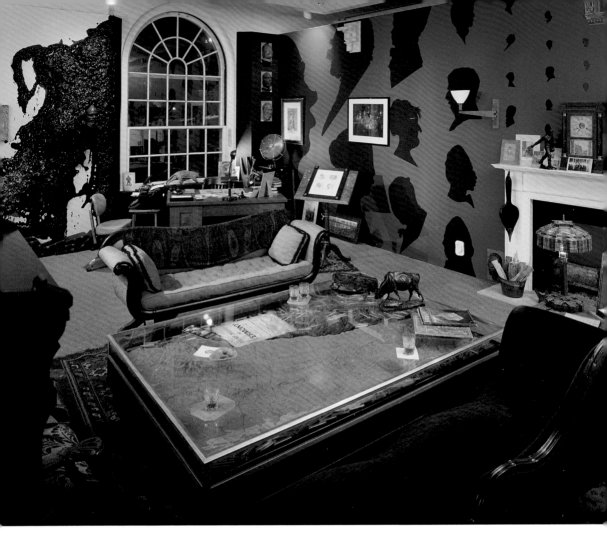

(above and facing; overleaf, details)
Long Shadows: Henry Perkins and
The Eugenics Survey of Vermont, 1995
Installation with video, painting, sound,
text, objects from the Fleming Museum
1200 square feet
Installation views, *Collective Histories,*
The Robert Hull Fleming Museum, University
of Vermont, Burlington, Vermont, 1995

Henry Perkins was a University of Vermont zoologist, the first
director of the Fleming Museum, and founder of the Eugenics
Survey of Vermont. Between 1925 and 1936, 4000 Vermonters
were interviewed with the express purpose of gathering data
to facilitate passage of sterilization legislation, which sought
to improve the human species through selective breeding.
Objects once belonging to Perkins were mixed with works
from the museum collection acquired during his tenure and
customized historical artifacts to explore issues of racism
and Vermont history.

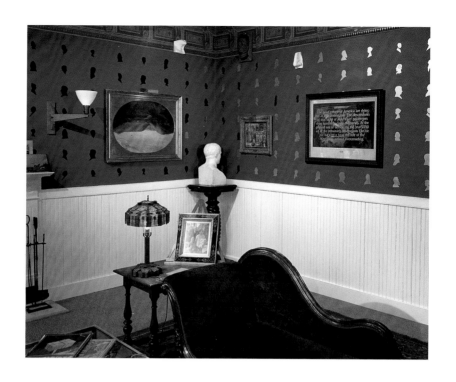

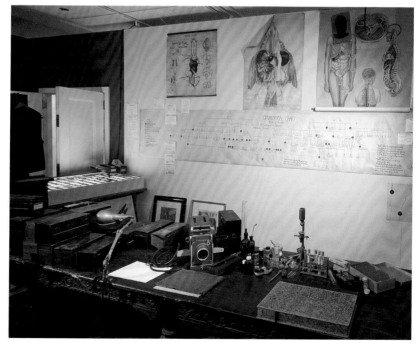

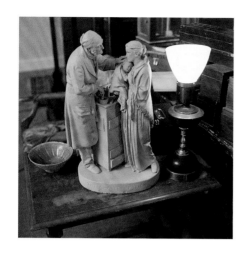

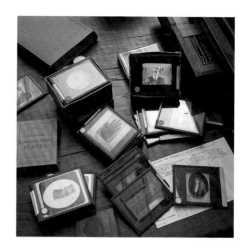

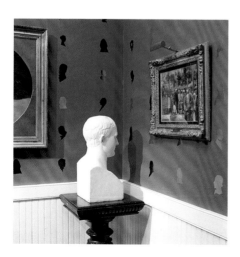

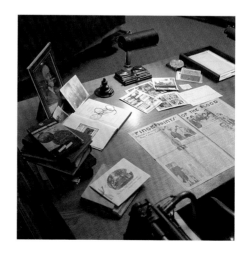

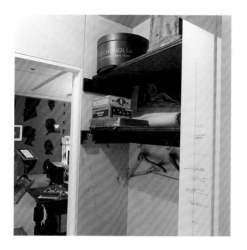
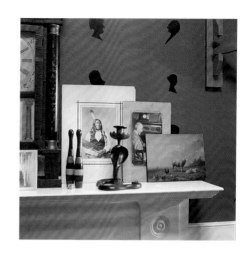
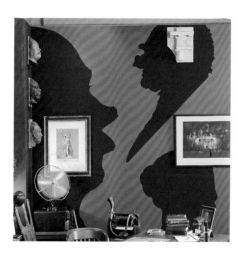
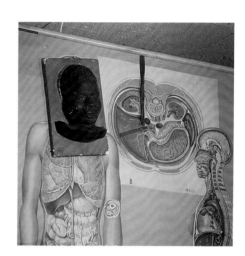

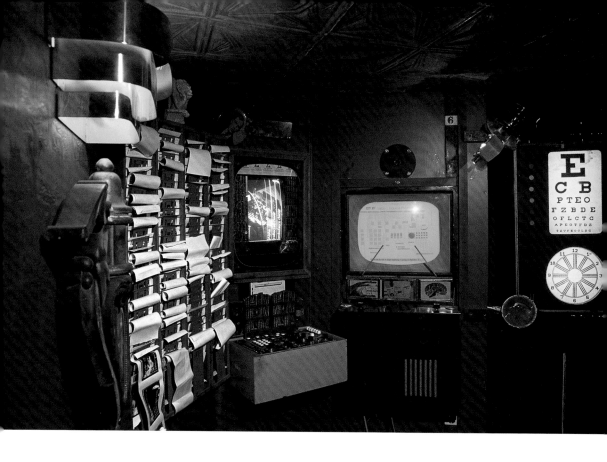

(this page and facing)
Michael Oatman and John J. A. Jannone
Tale of the Middleman (Un$_6$natural$_{12}$ Thirst$_6$), 1997
Installation with computer controlled audio
and video mixing and recording, slumped glass
liquor bottles, neon, electronically prepared
piano, paintings, furniture, historic electronic
equipment, and 22,000 bottles of ale craft-brewed
in collaboration with Magic Hat Brewing Company,
Burlington, Vermont
Variable dimensions
This page: Installation views, Exquisite Corpse
Artsite, Burlington, Vermont, 1997

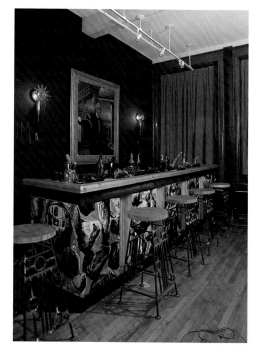

Installation views, RCCA: The Arts
Center, Troy, New York, 1997

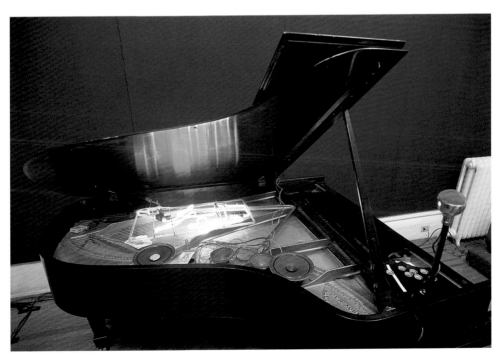

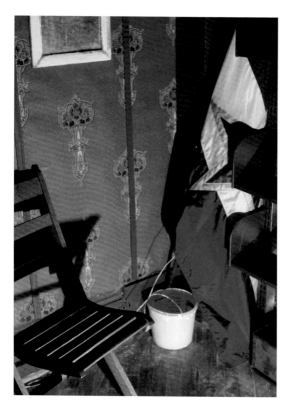

Throughout the 1990s, reports of deadly conflicts in the former Yugoslavian province of Kosovo were regularly broadcast on the nightly news. Statements by survivors of the ethnic conflict inspired Oatman's video response, which spells out their words in stop-action animation resembling a secret code. The ghostly books can represent a storehouse of past generations' knowledge threatened to disappear by war.

(this page and facing)
The Last Library (Kosovo Requiem), 1999
Installation with video, altered bronze sign, objects gathered from the abandoned Harmanus Bleecker Library, Yugoslavian flag, .22 caliber rifle, paper, restored air conditioning system lowering the room temperature to 50°, five versions of Henryk Górecki's *Symphony No. 3 (Sorrowful Songs)* played simultaneously and continuously.
Variable dimensions
Installation views, Phoenix Gallery, New York and *1999 Exhibition by Artists of the Mohawk-Hudson Region,* Albany Institute of History and Art, Albany, New York

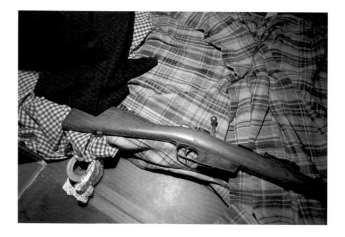

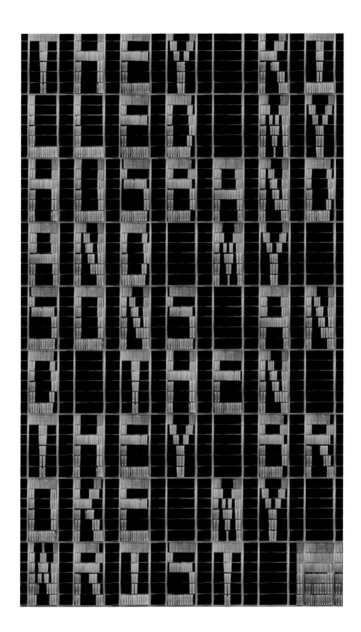

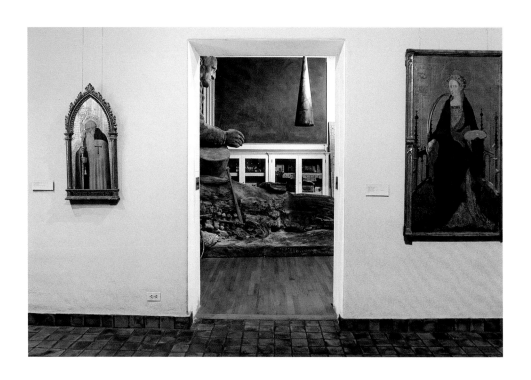

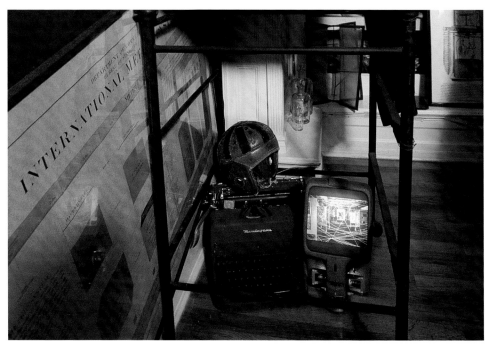

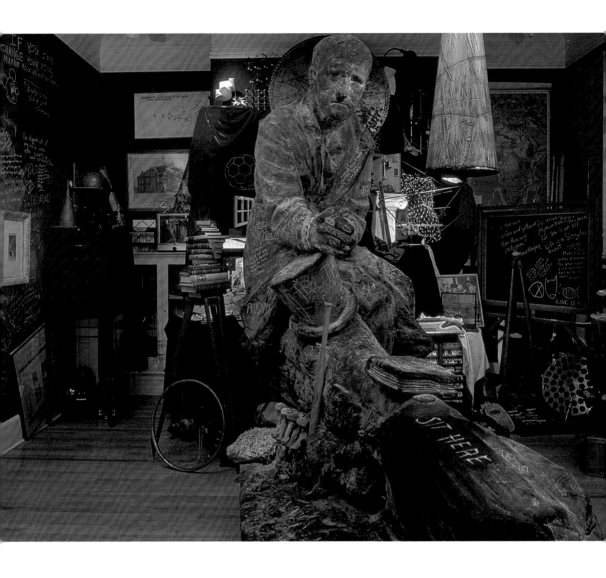

(this page and facing)
IDOL, 2002
Installation with sound and objects
from Williams College Collections
Installation views, Williams College
Museum of Art, Williamstown,
Massachusetts, 2002

Mark Hopkins was Professor of Moral Philosophy and President
of Williams College from 1836–1872. Former Hopkins pupil
and United States President James Garfield famously said
"The ideal college is Mark Hopkins on one end of a log and
a student on the other." Using a 1940s plaster model for a
sculpture depicting this scene by artist Henry Hudson Kitson,
Oatman created a room-filling installation that invited viewers
to sit under a dunce cap (inspired by a Goya-etching in the
museum's collection) to listen to over fifty one-minute lectures
by current Williams College faculty. Visitors were invited to
write on the chalk-board painted gallery walls and discover a
cornucopia of obsolete teaching tools collected from Williams
academic departments.

49

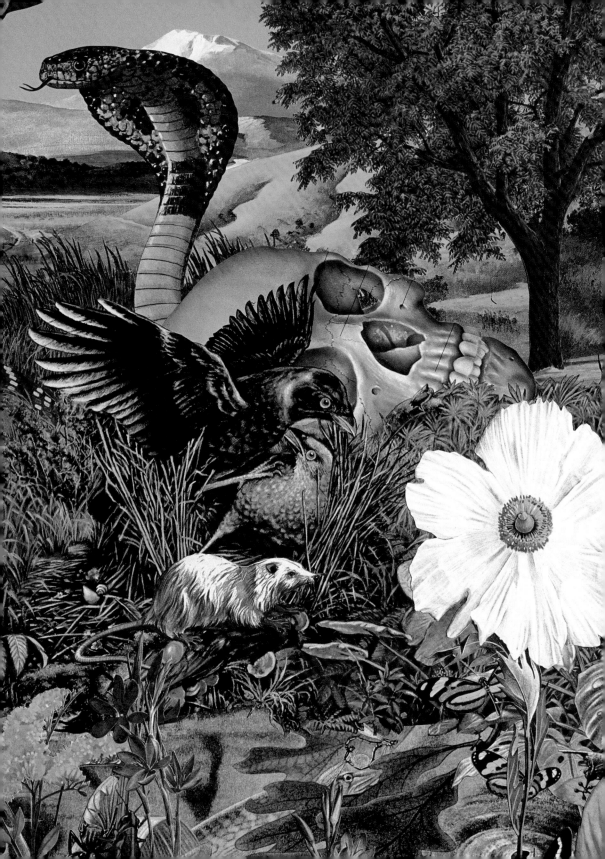

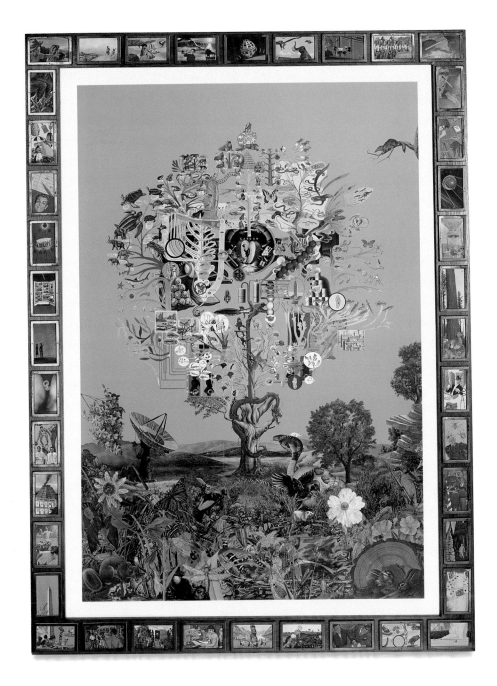

(this page, detail facing)
Anaximander, 2002
Collage on printed paper with mahogany
and brass predella frame
74⅝ x 54⅝"
Collection of Jim Gray, Lexington, Kentucky

(overleaf)
The Birds, 2002
Collage on printed paper with welded steel predella frame
88 x 145"
Albany Institute of History and Art, Albany, New York
Albany Institute Purchase; 2003 Artists of the
Mohawk-Hudson Region; 2003.14

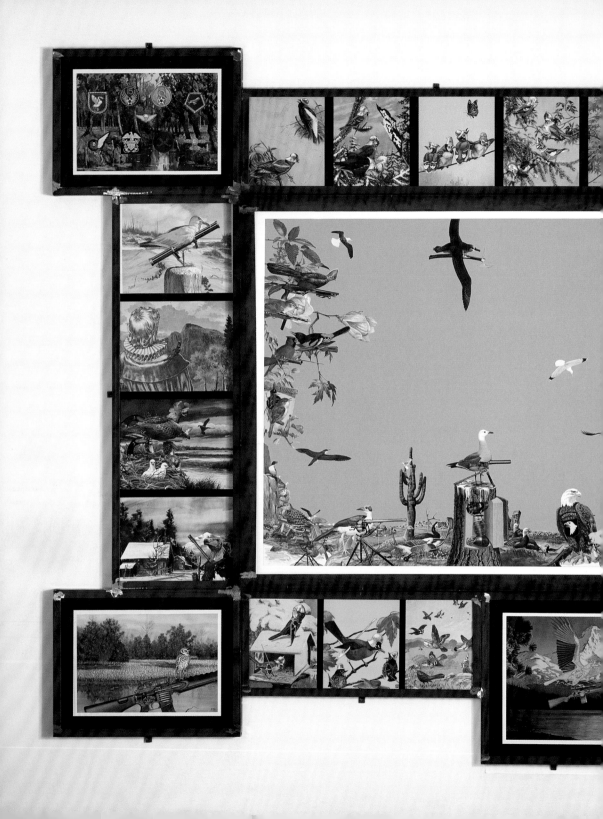

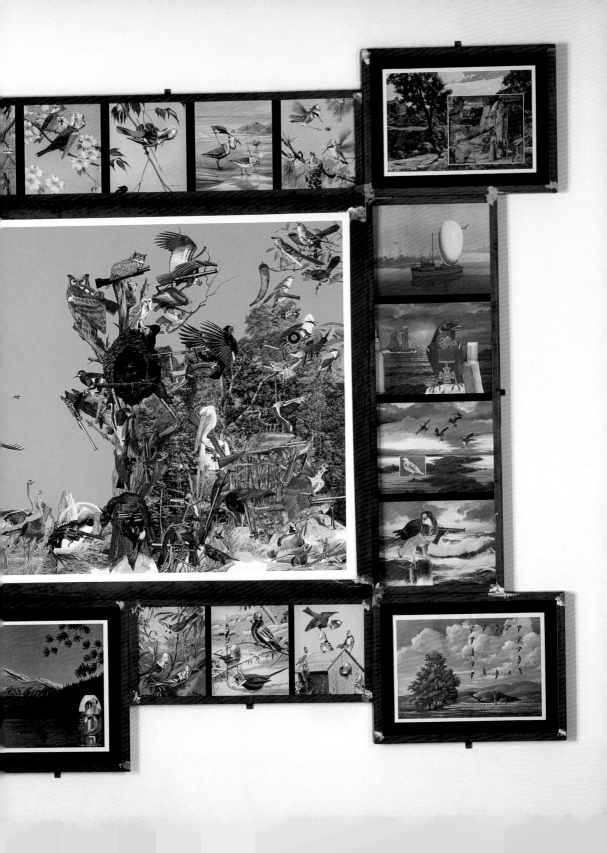

Growing up in Vermont, Oatman remembers grade
school field trips to the home of Wilson A. "Snowflake"
Bentley, the microphotography pioneer. At his Jericho,
Vermont farm, Bentley built a makeshift sub-zero lab in
order to study and photograph snow crystals. The fighter
planes recall a state of war readiness Oatman experienced
as a child during the 1960s and 70s.

Blanket, 2002
Collage and spray paint on paper
100 x 100"
Courtesy of the artist

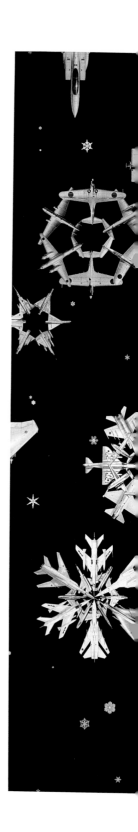

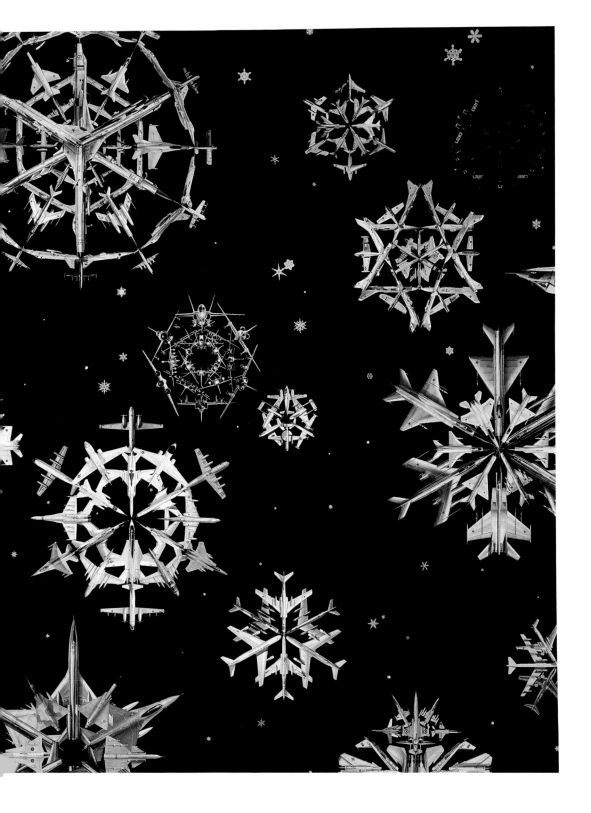

*Exurbia (more leisure time
for artists everywhere),* 2004
Collage and spray paint
on paper
54⁵/8 x 74¹/₂"
Museum of Fine Arts, Boston,
Massachusetts, M. Theresa B.
Hopkins Fund, 2006.1159

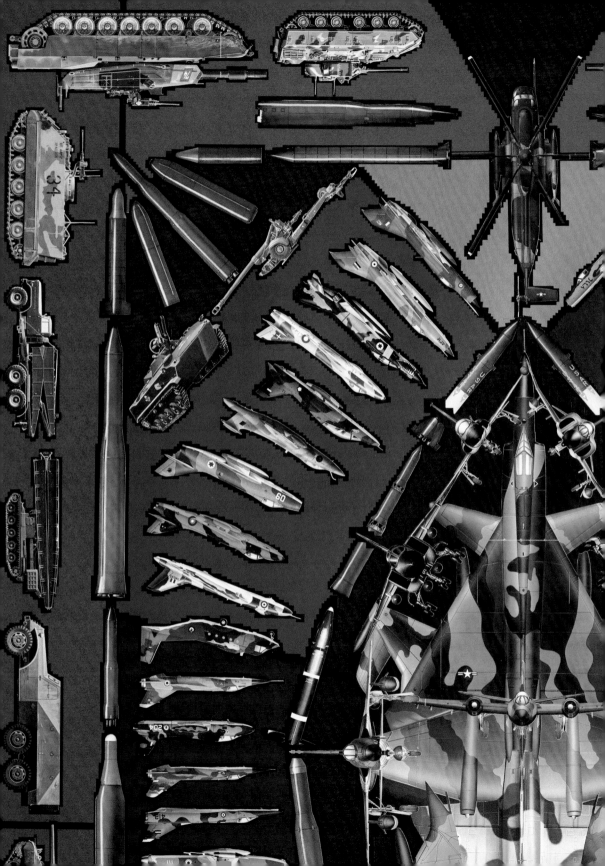

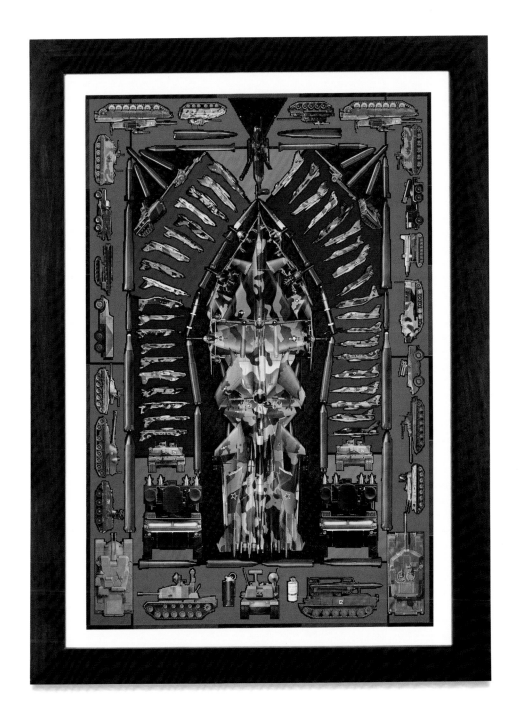

(this page, detail facing)
Flying Carpet (Kilim), 2004
Collage on paper
$74^{1}/_{2}$ x $54^{5}/_{8}$"
Courtesy of the artist

Towards a New Architecture, 2004
Collage on paper
25 1/2 x 24 3/4"
Collection of A. G. Rosen

Code of Arms, 2004
Collage on printed paper
with test tube rack frame
106 3/4 x 54"
Courtesy of the artist

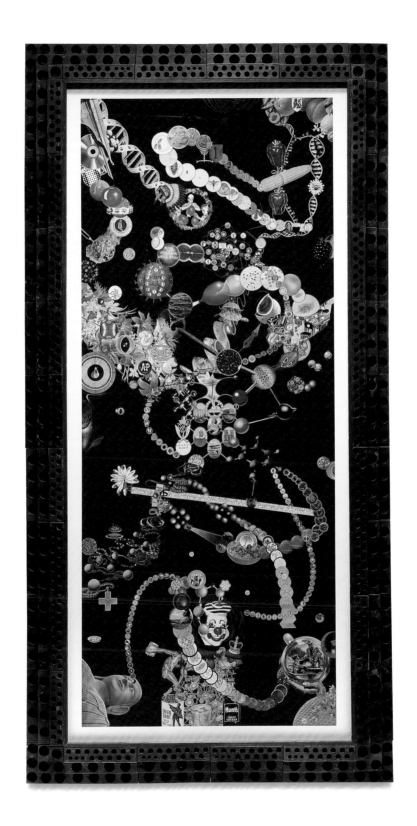

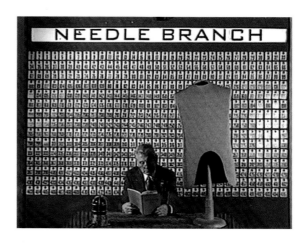

This artwork sets the stage for a Buster Keaton-esque farce filmed in the artist's former studio in Troy, New York. The narrative slowly reveals three workers at a fictional hotel that offers a button repair service. As two old-timers steadily work through the day's orders with calm and confident expertise, the new guy on the job quickly becomes tangled in his increasingly chaotic batch of orders.

(facing, video stills this page)
*A Lifetime of Service and
a Mile of Thread,* 2002
Mixed media with two videos
91 x 51 x 24" overall, videos:
3:26 minutes and 9:58 minutes
Courtesy of the artist

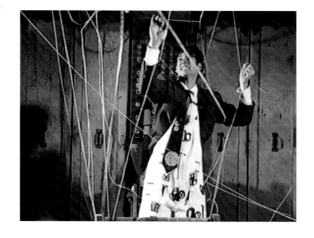

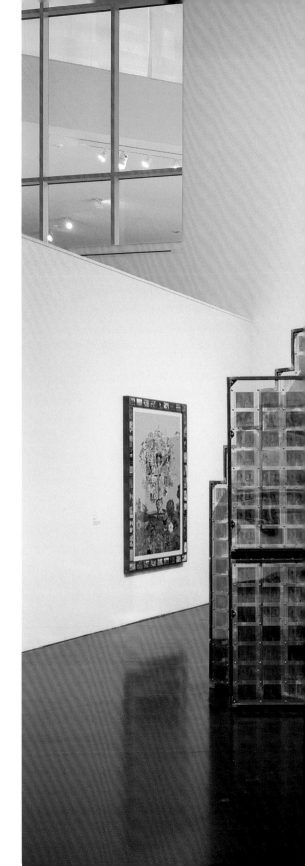

Historians recount that after the American Civil War there were so many discarded glass plate negatives on battlefields that property owners began to use them for greenhouse glass. In 1997 Oatman discovered an archive of 17,000 glass plate negatives of late 19th and early 20th-century criminal mug shots of individuals processed through The Albany County Jail, Albany, New York. Growing plants associated with evil such as the rose and nightshade are potted in the numbered wooden boxes that once held these glass plates. Douglas Johnson's haunting score for harmonica completes the eerie and eventually redemptive environment.

(this page, details on overleaf)
Michael Oatman with Falling Anvil Studios
Conservatory, 2005
Steel frame, 2,500 glass plate negatives, Plexiglas, hardware, crushed stone, gardening tools, forty wooden crates, soil, rose bushes and other various plants, audio; "Conservatory Songs" for harmonica composed and performed by Douglas Johnson.
120 x 144 x 216"
Courtesy of the artist and ZieherSmith, New York
Installation view, Tang Museum, Skidmore College, 2005

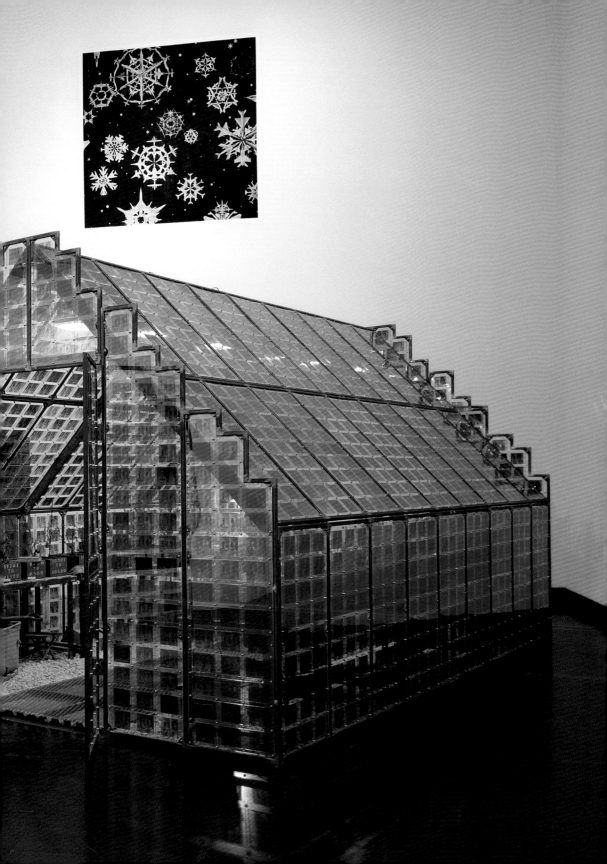

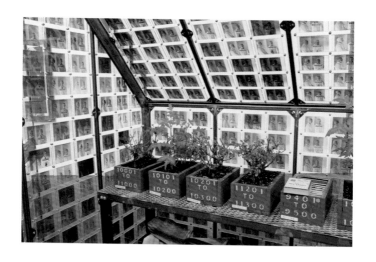

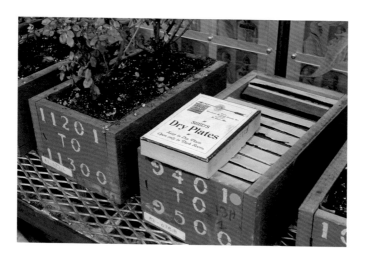

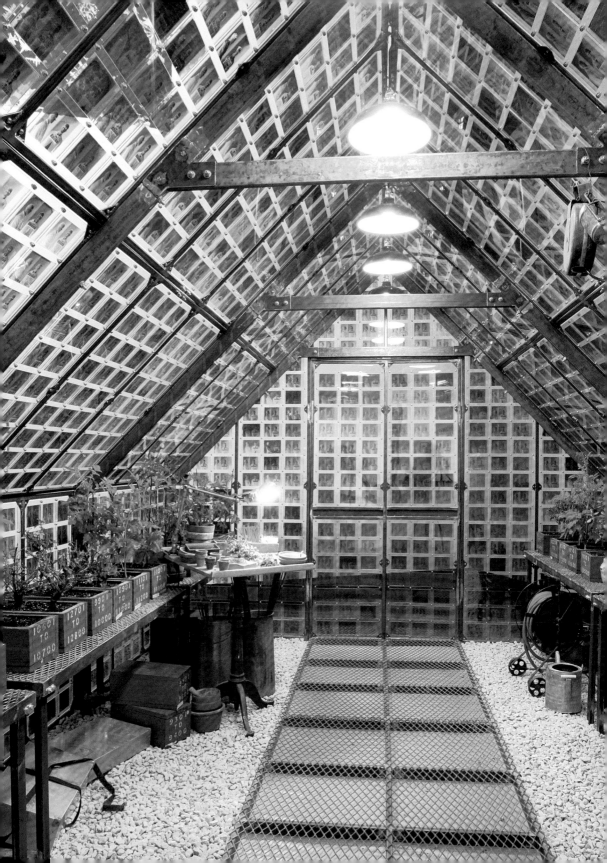

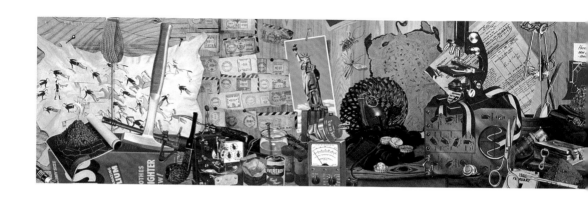

American Hobbyist (ganzfeld), 2004
Collage on paper
19 x 90 $^1/_2$"
Collection of Ninah and Michael Lynne

Tuesday: from a newspaper article about
the large number of personal effects, 2002
Collage on found architectural watercolor
$37\,^1/_2$ x $30\,^1/_2$"
Collection of Robert Rovenolt, Boston,
Massachusetts

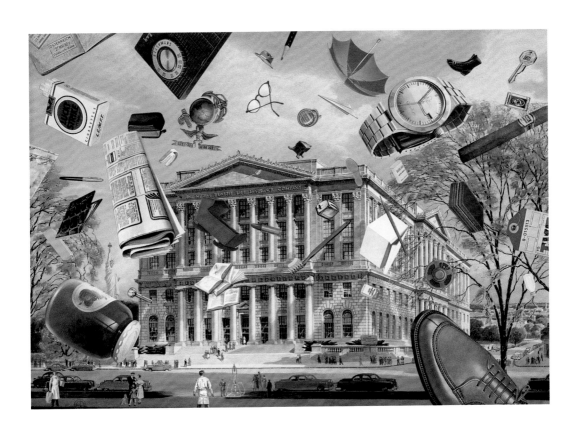

(this page and facing)
A Romance in Optics, 2005 (details)
Portable Tower Optical Binocular with shipping case,
photograph, embroidered hat, mannequin head and
display case, cast-iron sign, various maps, decal,
fifty pounds of world currency, video
Dimensions variable
Courtesy of the artist
Installation views, Tang Museum,
Skidmore College, 2005

Founded in 1932, Tower Optical Company, Norwalk,
Connecticut is the country's oldest manufacturer of coin-
operated binocular viewing machines, which are often
found near scenic views and historic sites. Oatman used
the viewers on Liberty Island in New York and then took
a specially made traveling viewer to Easter Island off the
coast of Chile to record different people's answer to the
repeated question, "If you could use this device to see
anything in the past, present, or future, a person, living
or dead, an historical event, or an event that has yet
to occur, what would you most desire to see?"

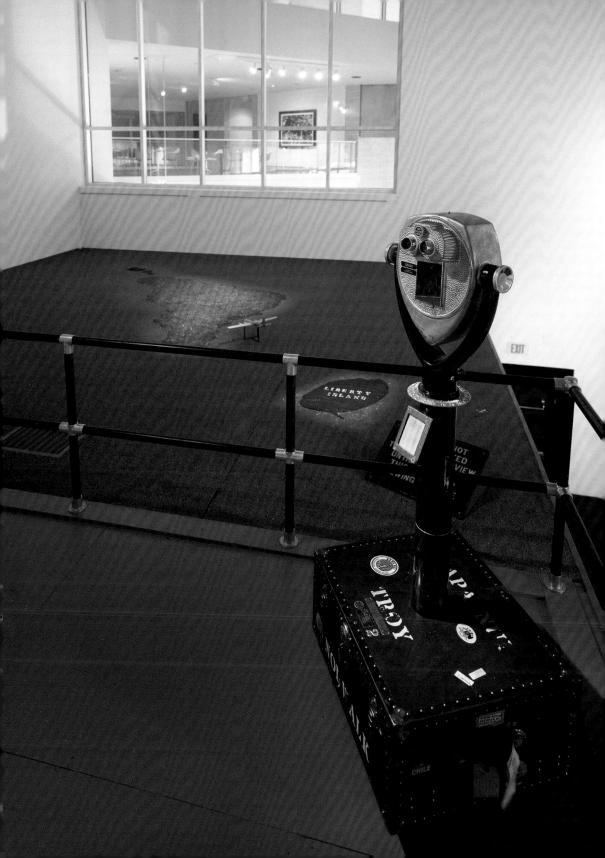

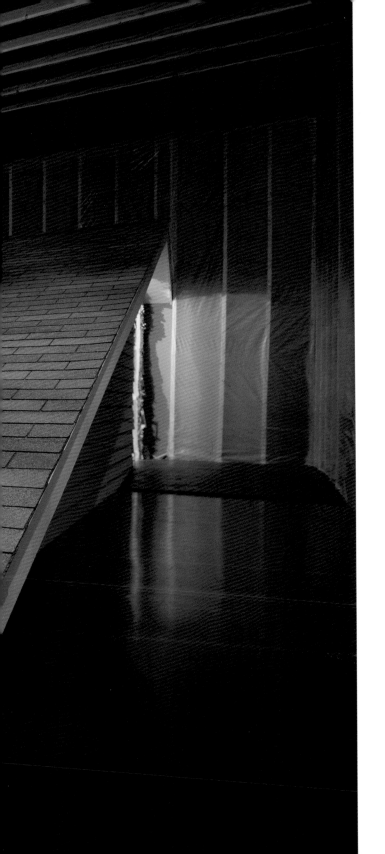

Iceberg, 2005
Mixed media installation with diorama,
beer can collection, record player, mirror,
fake brick, and twenty-six objects on
loan from family, friends, other artists
and makers who have served as
inspiration and influence
12 x 22 x 45 feet
Courtesy of the artist
Installation view, Tang Museum,
Skidmore College, 2005

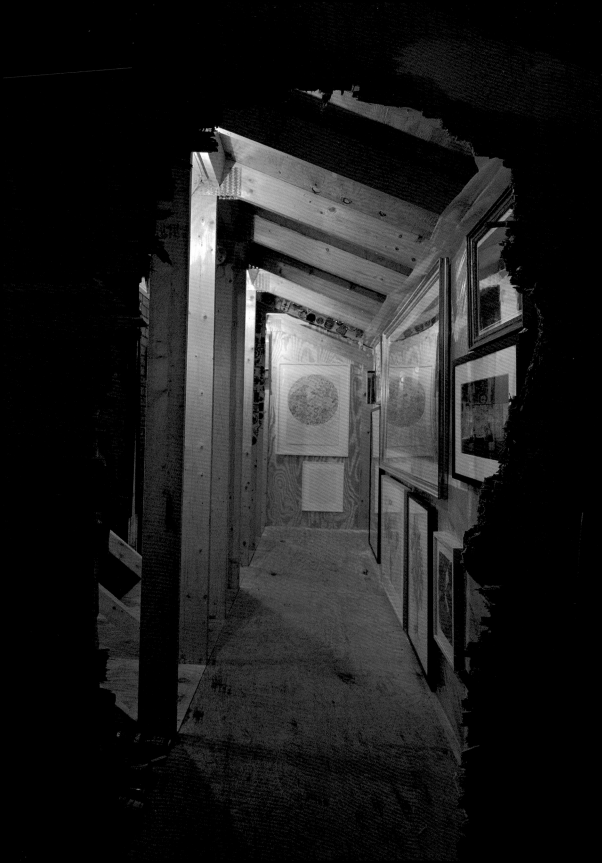

Iceberg, 2005 (details facing and overleaf)
Mixed media installation with diorama, beercan collection,
record player, mirror, fake brick, and twenty-six objects on loan
from family, friends, other artists and makers who have served
as inspiration and influence.
12 x 22 x 45 feet
Courtesy of the artist
Installation views, Tang Museum, Skidmore College, 2005

The following works were included in *Iceberg*.
All collection of Michael Oatman unless otherwise noted.

a. Alfred DeCredico
Untitled, 1988
Charcoal, acrylic and tempera
on prepared paper
Courtesy of Alfred DeCredico

b. Wesley Ernest Disney
Triptych of A Wall, 1981
Gelatin silver prints mounted
on acid-free paper
Collection of Janie Cohen

c. James Scott
Untitled, 2005
Watercolor on paper
Courtesy of James Scott

d. *Attributes of the Eight Great
Protectors of the Gelugpa Tradition*,
c. 19th century
Mineral pigments on cloth
Collection of the Rubin Museum
of Art, New York

e. JoAnne Carson
Untitled, 2004
Colored pencil on paper
Courtesy of JoAnne Carson

f. Dawn Clements
Untitled, c. 1991
Ink and pencil on paper

g. Shirley Oatman
Untitled (sock monkey painting),
c. 1997
Acrylic on canvas

h. Topp's Wacky Packages, 1979
Uncut decal sheet

i. Bo Joseph
Inferno: Hydra, 1999
Ink, oil, pastel, and tempera
on paper
Courtesy of Bo Joseph

j. Kate Ericson and Mel Ziegler
September 11, 1776 from *Time the
Destroyer is Time the Preserver*,
1986
Enamel on metal
Courtesy of Mel Ziegler

k. Lloyd Evans
Untitled, c. 1985
Oil, acrylic, collage and hair
on board
Courtesy of Todd Bartel

l. Mark Greenwold
Divorce #4, 1983
Ink and gouache on paper
Private Collection

m. Helen Martin
Red Barn, c. 1964
Watercolor
Courtesy of Gordon and
Shirley Oatman

n. Shirley Oatman
Untitled (portrait of Dad sleeping),
c. 1982
Ink on paper

o. Nancy Graves
*Untitled #127 (Drawing of
the Moon)*, c. 1970
Watercolor, gouache, and
pencil on paper
Nancy Graves Foundation, Inc.,
New York

p. Gordon Oatman
Chimney Model, c. 1990
Wood

q. John Hampson
George Washington, 1879
Insects, pins, glue, paper
The Fairbanks Museum and
Planetarium, St. Johnsbury,
Vermont

r. Edward Mayer
The Wall (Albany Academy), 1991
Photocollage
Courtesy of Edward Mayer

s. Brian Kane
This is a Pipe, c. 1985
Vacuum-formed plastic

t. Alfred DeCredico
Mid-50s Portrait of a Middle Class Girl, 2003
Acrylic, felt-tip marker and oil on canvas
Courtesy of Alfred DeCredico

u. Susan A.T. Clarke
Untitled, c. 1994
Silk, velvet, and pubic hair

v. *Battle of Bennington Commemorative Plate*,
c. 1890
Porcelain
Courtesy of Gordon Oatman

w. Todd Bartel
Surrender to Vastness, 2002
Mixed media construction
Courtesy of Todd Bartel

x. Man Ray and Marcel Duchamp
Rrose Sélavy, 1921
Photograph
On extended loan to The Frances Young Tang Teaching Museum and Art Gallery from a Private Collection

y. Jasper Johns
Target, 1970
Limited edition print and book

z. David Byrne and Brian Eno
My Life in the Bush of Ghosts, 1981
Record album

The Bookshelf

Auster, Paul. *The Locked Room*. The New York Trilogy, Vol 3. New York: Penguin Books, 1986.

Brumberg, Keith. *Plums and Dishes*. Limited edition chapbook, 21 of 50. Self-published, 1985.

Carlson, George. *Fun for Juniors*. New York: The Platt and Munk Co., Inc., 1937.

Christie, Agatha. *The Murder of Roger Ackroyd*, 1926. New York: Pocket Books, Inc., 1964.

Dixon, Franklin W. and Captain D.A. Spina. *The Hardy Boys Detective Handbook*. New York: Grosset and Dunlap, 1959.

Freuchen, Peter. *Arctic Adventure*. New York: Farrar and Rinehart, Inc., 1935.

London, Jack. *The Call of the Wild*, 1903. New York: London MacMillan Company, Ltd., 1915.

Parker, Bertha Morris. *The Golden Book of Science for Boys and Girls*. New York: Golden Press, Inc., 1963.

Queen, Ellery. *The Finishing Stroke*, 1958. New York: Pocket Books, Inc., 1963.

Wheatley, Dennis. *Murder Off Miami*, 1931. New York: Routledge Press, 1981.

Also included are objects lent by Tang Museum staff and crew that worked together to help build the piece

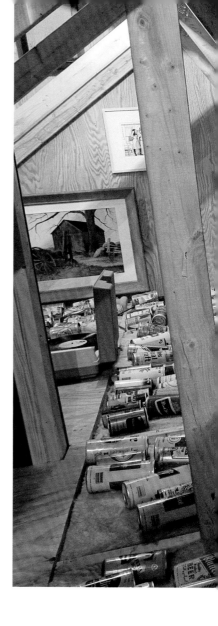

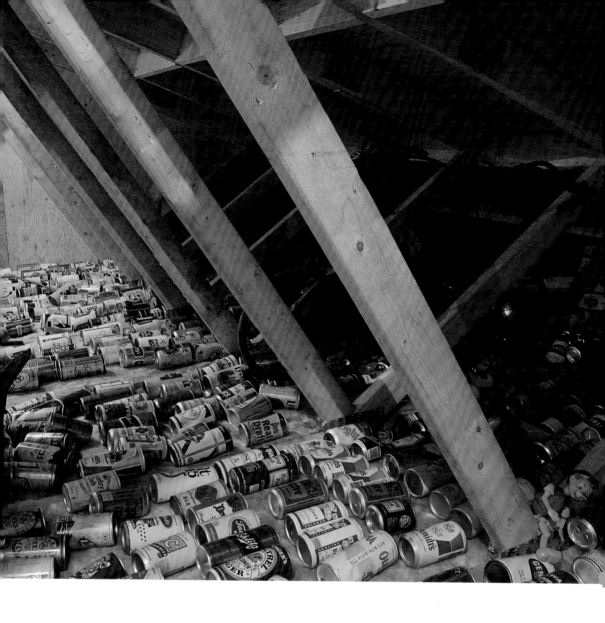

"Everything you see in this place, or rather in this store, was left here by the previous tenants,"
he replied. "So, you won't see much belonging to me here, but I prefer these instruments of chance.
The diversity of their nature doesn't allow me to limit myself to just one way of thinking,
and in this laboratory—where I inventory the resources systematically and, of course,
in the wrong way—my imagination exposes itself less to marking time."

—from *The Inventor of Gratuitous Time* by Robert Lebel, 1943–44

CHECKLIST

All works by Michael Oatman, courtesy of the artist, except
where noted; dimensions listed in inches, h x w x d

1. Assorted Sketchbooks and Artist Books,
1982–2005
Various media and dimensions

2. *A Boy's History of the World in 26 Volumes*,
1983
Twenty-six collages on paper
Each approximately 10 x 7"

3. *Prometheus*, 1990
Firebox with dustpan, broom, hammer,
chain, and sandblasted glass
$26\frac{1}{8}$ x 9 x $8\frac{1}{4}$"

4. *Ten Words or Less (other people's
memories)*, 1991
Type and ink on eleven found photographs
Each approximately $6\frac{1}{2}$ x $9\frac{1}{4}$"

5. *Identikit Self-portrait by Detective D. F. Swann,
Troy Police Department, Troy, N.Y.*, 1991
Photocopy and tape on Mylar
$12\frac{1}{2}$ x $16\frac{1}{2}$"

6. Michael Oatman with Gordon and
Shirley Oatman
In the Court of the Black King, 1994
Twelve sock monkeys with mahogany
and brass pillory
Dimensions variable

7. *The Last Library (Kosovo Requiem)*, 1999
Video
4:50 minutes

8. *Taken: 1° The Photograph, 2° The Confession
(traveling version)*, 2001
Mixed media with video
61 x $38\frac{1}{2}$ x 54", 81:17 minute video

9. *The Birds*, 2002
Collage on printed paper with welded steel
predella frame
88 x 145"
Albany Institute of History and Art, Albany,
New York,Albany Institute Purchase; 2003 Artists
of the Mohawk-Hudson Region; 2003.14

10. *Anaximander*, 2002
Collage on printed paper with mahogany
and brass predella frame
$74\frac{5}{8}$ x $54\frac{5}{8}$"
Collection of Jim Gray, Lexington, Kentucky

11. *A Lifetime of Service and a Mile of Thread*,
2002
Mixed media with two videos
91 x 51 x 24" overall,
videos: 3:26 minutes
and 9:58 minutes

12. Michael Oatman with Alan Okey
SYZYGY, 2002
Mixed media installation with video
5:55 minutes

13. *Tuesday: from a newspaper article about
the large number of personal effects*, 2002
Collage on found architectural watercolor
$37\frac{1}{2}$ x $30\frac{1}{2}$"
Collection of Robert Rovenolt, Boston,
Massachusetts

14. *Blanket*, 2002
Collage and spray paint on paper with
clear pushpins
100 x 100"

15. *Night Gallery (Observatory Time)*, 2003
Collage on paper
$24\frac{1}{4}$ x $49\frac{1}{4}$"
Private Collection

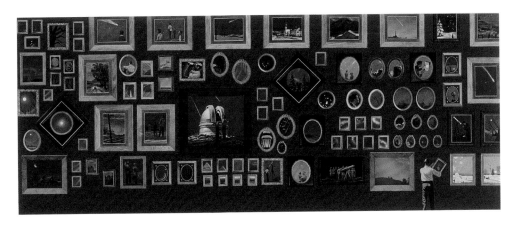

16. *Flying Carpet (Kilim)*, 2004
Collage on paper
74 1/2 x 54 5/8"

17. *Exurbia (more leisure time for artists everywhere)*, 2004
Collage and spray paint on paper
54 5/8 x 74 1/2"
Museum of Fine Arts, Boston, Massachusetts

18. *American Hobbyist (ganzfeld)*, 2004
Collage on paper
19 x 90 1/2"
Collection of Ninah and Michael Lynne

19. *No Two Alike*, 2004
Collage and spray paint on paper
Two panels, each 48 x 48"
The Boeing Company

20. *Towards a New Architecture*, 2004
Collage on paper
25 1/2 x 24 3/4"
Private collection

21. *Code of Arms*, 2004
Collage on printed paper with
test tube rack frame
106 3/4 x 54"

(above)
Night Gallery (Observatory Time), 2003
Collage on paper
24 1/4 x 49 1/4"
Private Collection

22. Michael Oatman with Falling Anvil Studios
Conservatory, 2005
Steel frame, 2,500 glass plate negatives, Plexiglas,
hardware, crushed stone, gardening tools, forty
wooden crates, soil, rose bushes and other
various plants, audio; "Conservatory Songs"
for harmonica composed and performed by
Douglas Johnson
120 x 144 x 216"
Courtesy of the artist and ZieherSmith, New York

23. Michael Oatman with Alan Okey
and Falling Anvil Studios
Nocturne (2125–8764), 2005
Video
26:08 minutes
Courtesy of the artist and ZieherSmith, New York

24. *A Romance in Optics*, 2005
Portable Tower Optical Binocular with shipping
case, photograph, embroidered hat, mannequin
head and display case, cast-iron sign, various
maps, decal, fifty pounds of world currency, video
Dimensions variable

25. Michael Oatman with Falling Anvil Studios
Iceberg, 2005
Mixed media installation with diorama, beer can
collection, record player, mirror, fake brick, and
twenty-six objects on loan from family, friends,
other artists and makers who have served as
inspiration and influence

26. A hidden work

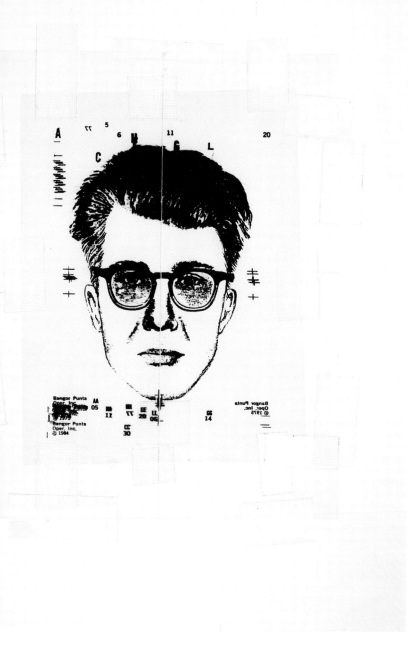

MICHAEL OATMAN

Born in Burlington, Vermont, in 1964
Lives and works in Troy, New York

Education
1992
M.F.A., University at Albany, Albany, New York

1986
B.F.A., Rhode Island School of Design, Providence, Rhode Island

Solo Exhibitions

2005
Michael Oatman: A Lifetime of Service and a Mile of Thread, The Frances
 Young Tang Teaching Museum and Art Gallery, Skidmore College, Saratoga
 Springs, New York, June 24–September 11
Conservatory, ZieherSmith, New York, February 12–March 12

2004
Jackknife: Collages by Michael Oatman, University of Wyoming Art Museum,
 Laramie, Wyoming, June 19–September 4

2002
Dowsing With a Knife: Recent Collages by Michael Oatman, Francis Colburn
 Gallery, University of Vermont, Burlington, Vermont, October 7

2001
IDOL: A New Work by Michael Oatman, Williams College Museum of Art,
 Williamstown, Massachusetts, April 7, 2001–March 31, 2002

1999
The Last Library (Kosovo Requiem), Phoenix Gallery, New York, November 3–
 November 27

1996
Murder and Other Wonders, Julian Scott Memorial Gallery, Johnson State
 College, Johnson, Vermont, November 7–December 22

1994
Shrapnel: Fragments from Installations 1985–1994, Griffin Graphics Gallery,
 Burlington, Vermont, September 9–October 5

*Identikit Self-portrait by Detective
D. F. Swann, Troy Police Department,
Troy, N.Y.,* 1991
Photocopy and tape on Mylar
$12^{1}/_{2}$ x $16^{1}/_{2}$"
Courtesy of the artist

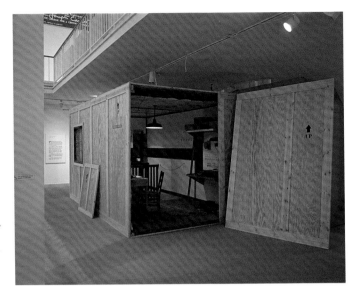

Taken: 1° The Photograph,
2° The Confession, 2000
Installation view, *Searching the*
Criminal Body: Art/Science/
Prejudice, University at Albany
Art Museum, Albany, New
York, 2000

Michael Oatman's Menagerie, Schacht Fine Arts Center, Russell Sage College
 Gallery, Troy, New York, January 10–February 12

1993
Michael Oatman Presents Robert MacKintosh: The Responsibilities of
 Disappearance, L/L Gallery, University of Vermont, Burlington, Vermont,
 February 26–March 18

1990
Frames of Reference, Webb and Parsons North, Burlington, Vermont,
 March 9–April 14

Selected Group Exhibitions

2006
Hybridity: The Evolution of Species and Space in 21st-Century Art,
 21c Museum, Louisville, Kentucky, April–October

2005
Becoming Animal, MASS MoCA, North Adams, Massachusetts,
 May 29, 2005–February 12, 2006
True North, MIA Gallery, Miami, Florida, February 3–May 8
Factory Direct: New Haven, Artspace, New Haven, Connecticut, January 22–
 April 2

2004
2004 Exhibition by Artists of the Mohawk-Hudson Region, Schenectady Museum
 and Planetarium, Schenectady, New York, July 24–September 3

Economical Food Circus, Contemporary Artists Center, North Adams,
 Massachusetts, July 16–August 15
War and Peace, Metaphor Contemporary Art, Brooklyn, New York, June 23–
 August 1
Michael Oatman and Sean Foley: Some Assembly Required, Mary Ryan Gallery,
 New York, April 8–May 8
For the Birds, Artspace, New Haven, Connecticut, January 17–March 20

2003

Parts of that Century: Objects for Joseph Cornell, ZieherSmith, New York,
 December 11, 2003–January 24, 2004
Suspended Narratives, Fine Arts Center Galleries, University of Rhode Island,
 Kingston, Rhode Island, October 9–December 8
2003 Exhibition of Artists of the Mohawk-Hudson Region, University Art
 Museum, University at Albany, Albany, New York, July 8–November 1
Living With Duchamp, The Frances Young Tang Teaching Museum
 and Art Gallery, Skidmore College, Saratoga
 Springs, New York, June 27–September 28
Unplugged: Painting in the Age of Technology,
 Albany International Airport Gallery, Albany,
 New York, May 19, 2003–January 4, 2004
*Tag: Recent Collages by Todd Bartel And
 Michael Oatman*, Lenore Gray Gallery,
 Providence, Rhode Island, April 4–May 1

2002

40 Artists, 40 Miles, The Arts Center of the
 Capital Region, Troy, New York, October 18,
 2002–January 19, 2003
*2002 Exhibition by Artists of the Mohawk-
 Hudson Region*, Albany Institute of History
 and Art, Albany, New York, June 15–August 25
The 2002 DeCordova Annual, DeCordova
 Museum and Sculpture Park, Lincoln,
 Massachusetts, June 8–September 1

2001

The Art of Illumination: Medieval to Modern,
 Manhattanville College Library, Purchase,
 New York, October 26–December 14
Art at the Edge of the Law, The Aldrich
 Contemporary Art Museum, Ridgefield,
 Connecticut, June 3–September 9
Issues of Identity in Recent American Art, The
 Gibson Gallery, State University of New York
 at Potsdam, Potsdam, New York, March 12–
 April 22; Traveled to University Galleries,

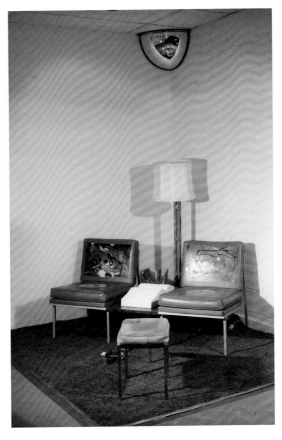

Hounding, 1993
Installation view, *Volume 1*,
Boulevard Project Space,
Albany, New York

Illinois State University, Normal, Illinois, June 12–September 9; Ewing Gallery of Art and Architecture, University of Tennessee, Knoxville, Tennessee, October 1–November 8; Ben Shahn Galleries, William Paterson University, Wayne, New Jersey, January 31–March 8, 2002; Samek Art Gallery, Bucknell University, Lewisburg, Pennsylvania, March 18–April 14, 2002

2000

Searching the Criminal Body: Art/Science/Prejudice, University Art Museum, University at Albany, Albany, New York, September 23–November 5

Unnatural Science, MASS MoCA, North Adams, Massachusetts, June 3, 2000– May 2001

What's the Big Idea?, Contemporary Artists Center, North Adams, Massachusetts, June–July

Tontine, Hermen Goode Gallery, Brooklyn, New York, May 13–June 24

1999

1999 Exhibition by Artists of the Mohawk-Hudson Region, Albany Institute of History and Art, Albany, New York, June 24–August 22

1998

A Romance in Optics, 1993–96
Installation view,
The Downtown Troy Windows Project, Troy, New York

Into Focus: Art on Science, Mandeville Gallery, Nott Memorial, Union College, Schenectady, New York, August 20–October 11

Hunters, Gatherers: Artists As Collectors, RCCA: The Arts Center (now called The Arts Center of the Capital Region), Troy, New York, April 3–May 9

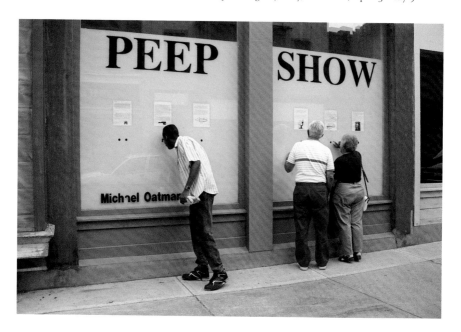

1997

Fourth International Biennial of Drawing and Graphic Arts, Városi Müvészeti Múzeum, Györ, Hungary, December 6, 1997–February 1, 1998

1997 Artists of the Mohawk-Hudson Region Juried Exhibition, University Art Museum, University at Albany, Albany, New York, June 17–July 31

Tale of the Middleman (Un₆natural₁₂ Thirst₆), RCCA: The Arts Center (now called The Arts Center of the Capital Region), Troy, New York, March 7–April 26; Traveled to Exquisite Corpse Artsite, Burlington, Vermont, May 9–June 20

1996

Paper, Firehouse Gallery, Burlington, Vermont

1995

Collective Histories: Installations by Suzanne Bocanegra and Michael Oatman, The Fleming Museum, University of Vermont, Burlington, Vermont, September 29–December 15

Hidden Histories, Albany Center Galleries, Albany, New York, June 30–August 18

1994

1994 Artists of the Mohawk-Hudson Region Juried Exhibition, University Art Museum, University at Albany, New York, June 7–July 31

1993

Monitor 93: The Second Coming of the Cryptics, Video as Art Festival, Frolundo Kulturhus and Göteborgs Kunstmuseum, Frolundo, Götesborg, Sweden, February 16–March 21

Volume 1, Boulevard Project Space, Albany, New York, February 5–March 19

1992

Politics and Art, Levinson/Kane Gallery, Boston, October 17–November 14

Goodbye to Apple Pie: Contemporary Artists View the Home in Crisis, DeCordova Museum and Sculpture Garden, Lincoln, Massachusetts, September 19–November 29

Vox Corporis: Wounds of our Time, Boulevard Project Space, Albany, New York, March 20–May 1

The Downtown Troy Windows Project: A Romance in Optics, 296 River Street, Troy, New York

1991

The Home Show: Reflections on the Home and Family, Levinson/Kane Gallery, Boston, September 7–October 12

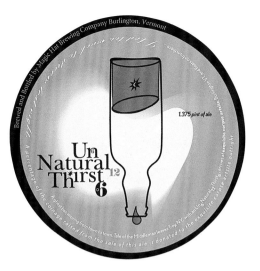

Michael Oatman with David Coval of Jager Di Paola Kemp Design
Beer bottle label for
Un₆natural₁₂ Thirst₆
Magic Hat Brewing Company,
Burlington, Vermont, 1997

The View From Here, Claremont Graduate School Galleries, Claremont, California, August 19–September 6

1991 Artists of the Mohawk-Hudson Region Exhibition, University Art Gallery, University at Albany, State University at Albany, Albany, New York, July 16–September 8

Second Thoughts, Schacht Fine Arts Center, Russell Sage College, Troy, New York, February 4–March 10

1990

T.E. Breitenbach, Gayle Johnson, Michael Oatman, RCCA: The Arts Center (now called The Arts Center of the Capital Region), Troy, New York, November 30–January 6, 1991

1990 Exhibition by Artists of the Mohawk-Hudson Region, Albany Institute of History and Art, Albany, New York, June 23–August 26

Flower, Russell Sage College Gallery, Schacht Fine Arts Center, Troy, New York, March 19–April 29

Redlining the Turtle, 2000 Installation view, *What's the Big Idea?*, Contemporary Artists Center, North Adams, Massachusetts

1989

Jeff Quinn and Mike Oatman: Pictures, Lenore Gray Gallery, Providence, Rhode Island

BIBLIOGRAPHY

Selected Books and Catalogues

Anker, Suzanne, and Dorothy Nelkin. *The Molecular Gaze: Art in the Genetic Age.*
Cold Spring Harbor, New York: Cold Spring Harbor Laboratory Press, 2004.

Bates, Sharon. *True North.* Exhibition catalogue. Miami, Florida: Miami International
Airport Gallery, 2005.

—. *Unplugged: Painting in the Age of Technology.* Exhibition brochure. Albany,
New York: Albany International Airport Gallery, 2003.

Bernstein, Roberta, ed. *Flower.* Albany, New York: Russell Sage College Gallery, 1990.

Berry, Ian. *Michael Oatman: A Lifetime of Service and A Mile of Thread.* Exhibition
catalogue. Saratoga Springs, New York: Tang Teaching Museum and Art Gallery, 2006.

Capasso, Nicholas. *Goodbye to Apple Pie: Contemporary Artists View the Family in
Crisis.* Exhibition catalogue. Lincoln, Massachusetts: DeCordova Museum and
Sculpture Park, 1993. Essay by Tamara K. Hareven.

Cohen, Janie. *Long Shadows: Henry Perkins and the Eugenics Survey of Vermont
(Vermont Pure).* Exhibition brochure. North Adams, Massachusetts: MASS MoCA,
2000.

Dell, Roger. *Tontine.* Exhibition catalogue. New York: Hermen Goode Gallery and
Unfoldingobject, 1999.

Dorin, Lisa. *Idol: A New Work by Michael Oatman.* Exhibition brochure. Williamstown,
Massachusetts: Williams College Museum of Art, 2001.

Edwards, Bree. "Incision: An Interview with Michael Oatman." *Dowsing with a Knife:
Recent Collages by Michael Oatman.* Exhibition brochure. Burlington, Vermont:
Colburn Gallery, University of Vermont, 2002.

Erony, Susan and Nicole Hahn Rafter. *Searching the Criminal Body: Art/
Science/Prejudice.* Exhibition catalogue. Albany, New York: University Art Museum,
University at Albany, State University of New York, 2000.

Fassbinder, Horant, ed. *Through the 'Net: Studies in Jochen Gerz "Anthology of Art."*
Cologne: Salon Verlag, 2004.

Gallagher, Nancy. *Breeding Better Vermonters: The Eugenics Project in the Green
Mountain State.* Hanover, New Hampshire: University Press of New England, 1999.

Glier, Mike. "Juror's Essay and Field Guide to Artists." *1999 Exhibition by Artists of the
Mohawk-Hudson Region.* Exhibition catalogue. Albany, New York: Albany Institute
of History and Art, 1999.

Heon, Laura Steward. *Unnatural Science.* Exhibition catalogue. North Adams,
Massachusetts: MASS MoCA, 2000.

Klien, Adrienne. *Into Focus/Art on Science.* Exhibition catalogue. Schenectady,
New York: Mandeville Gallery, Union College, 1998. Essay by Joachim Frank.

Klein, Richard. *Art at the Edge of the Law.* Exhibition catalogue. Ridgefield,
Connecticut: The Aldrich Contemporary Art Museum, 2001.

Lail, Thomas. "Lies and Deceptions: Mythic Structures and Middle-Men." *Tale of
the Middleman (Un$_6$natural$_{12}$ Thirst$_6$).* Exhibition brochure. Troy, New York: RCCA:
The Arts Center, 1997.

Markonish, Denise. *For the Birds*. New Haven, Connecticut: Artspace, 2003. Essay by
Michael Crewdson.

Mills, Dan. *Issues of Identity in American Art*. Exhibition catalogue. Potsdam,
New York: Roland Gibson Gallery, State University of New York at Potsdam, 2001.
Essay by Grady T. Turner.

Ripps, Corinna. *Hidden Histories*. Exhibition brochure. Albany, New York: Albany
Center Galleries, 1995.

Rosenfield Lafo, Rachel, Nick Capasso, George Fifield and Jennifer Uhrhane. *The 2002
DeCordova Annual*. Exhibition catalogue. Lincoln, Massachusetts: DeCordova
Museum and Sculpture Park, 2002.

Thompson, Nato, ed. *Becoming Animal*. Exhibition catalogue. Cambridge and
North Adams, Massachusetts: MIT Press and MASS MoCA, 2005.

Tolnick, Judith. *Suspended Narratives*. Exhibition brochure. Kingston, Rhode Island:
Fine Arts Center Galleries, University of Rhode Island, 2003.

Selected Articles and Reviews

Alcedo, Gladys. "Exhibit tells story of man's relation to animal world." *Troy Record*
(16 January 1994): C1+.

Aletti, Vince. "Shortlist: Michael Oatman." *Village Voice* L, no. 8 (23 February 2005):
40–41.

Bjornland, Karen. "Art out of Barbarism." *Schenectady Daily Gazette* (24 September
2000): G1+.

—. "Exhibit testimony to Oatman's curiosity, imagination." *Schenectady Daily Gazette*
(2 September 2005): D5.

Boardman, Andrew, ed. *New Observations*, no. 115 (Summer 1997).

Brickman, David. "In the Presence of Greatness." *Metroland* 28, no. 26 (30 June 2005):
38.

Buckeye, Robert. "Long Shadows: Henry Perkins and the Eugenics Survey of Vermont:
An installation by Michael Oatman." *Art New England* 17 (February/March 1996): 68.

Cahill, Timothy. "18 painters' art 'Unplugged' with emphasis on technology." Summer
Arts Review, *Albany Times Union* (8 June 2003): 19.

—. "Here's a Theory: Artist, Criminologist Team for 'Searching the Criminal Body.'"
Albany Times Union (29 September 2000): D1.

Cowan, Alison Leigh. "When a Factory is a Foundry for Art." *New York Times* (9
February 2005): E1.

Gardner, Karen. "Artist Re-creates Controversial Vermont Moment." *North Adams
Transcript* (15 July 2000): B9.

Genocchio, Benjamin. "A Marriage of Art and Industry." *New York Times* (27 February
2005) Sec. 14CN: 11.

Glueck, Grace. "The Line Between Species Shifts, and a Show Explores the Move."
New York Times (26 August 2005): E2+.

Gurewitsch, Matthew. "At MASS MoCA, Vast Spaces and Scientific Fantasies."
Wall Street Journal (8 July 2000): A20.

Haymes, Greg. "Brainspace Narratives." *Albany Times Union* (21 August 2005): I1+.

Jaeger, William. "Art (as) History: Glimpse of past preserved in 'Hidden Histories' exhibit." *Albany Times Union* (23 July 1995): G4.

——. "Factory Direct 1 + 2." *Art New England* (October/November 2002): 37.

——. "Rooms with a Viewpoint." *Albany Times Union* (27 May 2001): I1.

——. "Tale of the Middleman' a collaborative effort." *Albany Times Union* (30 March 1997): G2.

Kernan, Nathan. "Unnatural Science." *Burlington Magazine* 142, no. 1172 (November 2000): 720–22.

Lauren, Stacy. "Searching the Criminal Body: Art/Science/Predjudice." *Art New England* 22, no. 1 (December 2000/January 2001): 44-45.

Lisi, Michael. "Neither Man nor Beast." *Albany Times Union* (26 May 2005): P18.

McQuaid, Cate. "Art's the Big Idea in North Adams." *Boston Sunday Globe* (23 July 2000): N2.

——. "DeCordova Annual is Full of Surprises." *Boston Globe* (19 June 2002): D1.

Parris, Nina. "Michael Oatman." *Art New England* 24, no. 2 (February/March 2003): 33.

Polston, Pamela. "Gene Pool." *Seven Days* (4 October 1995): 7.

Rinaldi, Ray Mark. "Oatman's Art Inhabits a Creepy World." *Albany Times Union* (30 January 1994): G2.

Rodriguez, Bill. "Dream Weavers." *Providence Phoenix* (31 October 2003) Art Section: 1+.

Rondeau, Mark E. "What Happens when Artists Interact with a Berkshike City?" *Berkshire Advocate* (12 July 2000): 1.

Shepard, Rebecca. "Brushes with Greatness." *Metroland* 26, no. 24 (12 June 2003): 32.

——. "Only Connect." *Metroland* 26, no. 32 (7 August 2003): 32.

——. "Tang show a personality study." *Albany Times Union* (7 August 2005): I1+.

Silander, Liisa. "Making a Tontine." *RISD Views* (Fall 2000): 39.

Silver, Joanne. "Opposites attract at annual DeCordova." *Boston Herald* (16 June 2002): A9.

Smith, Roberta. "In Their Own Worlds: Giant Hybrids of Fact and Fantasy." *New York Times* (11 August 2000): E33.

Sutherland, Scott. "Michael Oatman Presents: Robert MacKintosh & The Responsibilities of Disappearance." *Art New England* (June/July 1993): 61.

Temin, Christine. "At DeCordova, a piercing look into family secrets." *Boston Globe* (25 September 1992): 27.

——. "Unnatural Selection at MASS MoCA." *Boston Globe* (28 July 2000): D1.

Valdez, Sarah. "Outlaws in Art Land." *Art in America* 89, no. 11 (November 2001): 77.

Wright, Peg Churchill. "'Hidden Histories' artists personally interpret moments in time." *Schenectady Daily Gazette* (6 July 1995): A8.

——. "'Menagerie' explores Eurocentric guilt with Animal Imagery." *Schenectady Daily Gazette* (27 January 1994): A9.

Zimmer, William. "The Long Arm of the Law Reaches into the Gallery." *New York Times* (15 July 2001): 14CN, 11.

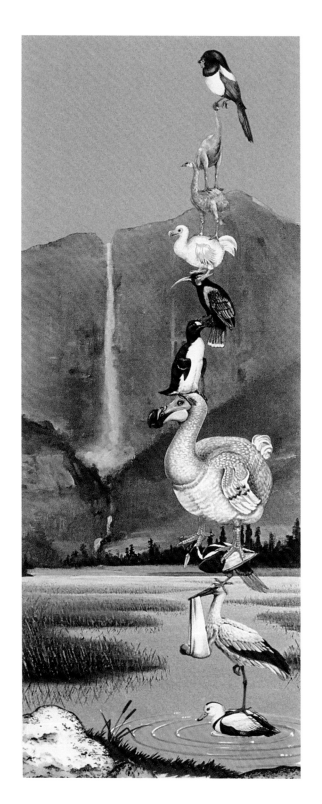

Ladder, 2003
Collage on paper
Collection of Cheryl Ryder,
Seattle, Washington

ACKNOWLEDGMENTS

Not many exhibitions affect the life of an institution so wholly that you can't imagine the place ever being the same again. *Michael Oatman: A Lifetime of Service and a Mile of Thread*, the ninth in the Tang's Opener series, had just that effect. It was our most ambitious building project yet in the gallery and because of that it brought us together as a team like no other time before. Michael's work not only challenged our physical and technical capabilities, but throughout the process he challenged our assumptions and habits that even for a young institution were already firmly in place.

Michael brought his students from Rensselaer Polytechnic Institute and Falling Anvil Studios to the table and all of us took part together in a great learning experience. For their help with the new work, *Iceberg*, and many other details of the exhibition thanks to Matthew Fickett, Stephanie Cramer, Erin Cusker, Shefali Sanghvi, John Edwards, Jenna Beltram, Nick Liberis, Becky Simkins, Moniera Buck, Melinda Freeze, and Aleksandr Prusakov. Also thanks to Skidmore students Julia Carlson, Megan Isaacs, Laura Beshears, Caitlin Woolsey, Lindsey Fyfe, Erin Barach, Martina Nagyova, Justin Hirsch, Annie Powers, and Kira Limer for their assistance.

Special thanks to the lenders to the exhibition: Albany Institute of History and Art, Todd Bartel, Joanne Carson, Janie Cohen, Alfred DeCredico, Fairbanks Museum and Planetarium, Nancy Graves Foundation, Inc., Bo Joseph, Edward Mayer, Gordon and Shirley Oatman, A. G. Rosen, Rubin Museum of Art, James Scott, Mel Ziegler, ZieherSmith, a private collection, and the artist. Thanks to the intrepid funders of the Opener series: the New York State Council on the Arts, The Laurie Tisch Sussman Foundation, The Overbrook Foundation, and the Friends of the Tang.

The project was one of the first for incoming Tang Director John Weber to watch come to life. We are most grateful for his encouragement along the way. The whole Tang staff was part of the team—thanks to Ginger Ertz, Lori Geraghty, Elizabeth Karp, Susi Kerr, Gayle King, Patrick O'Rourke, and Barbara Schrade. Very special thanks to Curatorial Assistant Ginny Kollak. My greatest appreciation goes to Chris Kobuskie and Nicholas Warner and our great crew: Sam Coe, Abraham Ferraro, Torrance Fish, Laura Frare, Laura Kiefer, Steve Kroeger, Dan O'Connor, Chris Oliver, Jason Thomas, Jay Tiernan, Joe Yetto, and Adala

Zelman, and Lindsey Christie for their incredible work making this mammoth exhibition in a very short time.

Thank you to Michael's parents, Gordon and Shirley Oatman, and to video editor Alan Okey for his fine craft and technical assistance. Bethany Johns has made an amazing publication to accompany the project, Art Evans photographed the works wonderfully, and Jay Rogoff helped edit with great skill. Lastly, our fondest appreciation goes to Michael, who has made an imprint on the museum and on all of us that will last for many years to come. Thank you for your hard work and your trust in letting us be a part of this moving and important body of work.

—IAN BERRY

There are many people to thank for their support. Thanks to my family: Gordon and Shirley Oatman, Tom and Gretchen Oatman, Anne, Gordon II, Katherine, and Matthew, and thanks to Falling Anvil Studios: Alan Okey, Erin Cusker, Stephanie Cramer, Matthew Fickett, Jenna Beltram, Moniera Buck, John Edwards, Craig Hoffman, Derek Keil, Nick Liberis, Alexandr Prusakov, Charlotte Root, Shefali Sanghvi, and Becky Simkins.

Thanks to Cinzia Abbate, Paul Aschenbach, Alan Balfour, Doug Bartow, Mark Bailey, Todd Bartel, Sharon Bates, Ed Beason, D. Bell, the Bell family, Ernst Benkert, Roberta Bernstein, Monica Berry, Kathleen Bitetti, David Boulanger, Frances Bronet, Keith Brumberg, Jay Burns, Nick Capasso, Lindsey Christie, Bernie Caron, JoAnne Carson, Judy Catelli, Peter Chevako, Susan Clarke, Dawn Clements, Janie Cohen, Kiera Coffee, Christopher C. Cook, Lisa Corrin, Richard Criddle, Julia Davies-Healy, Gerry Davis, Greg Davis, Jocelyn DeFazio, Christine Dickson, Jim Dine, Mark Dion, Philip Djwa, Lisa Dorin, Elizabeth Dove, Alice Drinkwater, John Dumas, Anna Dyson, Bree Edwards, Ross and Lorraine Edwards, Kate Ericson, Jefferson Ellinger, David Ely, Virginia Eubanks, Lloyd Evans, Garland Farwell, Lori Farrow, Abraham Ferraro, Anne Fiorillo, Justin and Susan Fite, Sid Fleisher, R.A. Forkie, Tara Fracalossi, Ruth Furman, Lindsey Fyfe, Mike Glier, Jake Gouverneur, Chris Graf, Ray Graf, Tracy Grimm, Mark Greenwold, Kathy Greenwood, Ms. Halstead, Homer and Marge Harding, Jeff Hatfield, Rick Hayes, Chelly and Padraic Hegan, Laura Heon, Danny Horsford, Mrs. Hultz, Paul Irish, Marge Isham, George Jacobs, John Jannone, Doug Johnson, Ken Johnson, Jeff Jones, Bo Joseph, Kristin Jung, Larry Kagan, Brian Kane, Joe Keyser, Richard Klein, Ted and Jean Krueger, Marc LaChappelle, Thom Lail, Audrey Larkin-Zurlo, Mike Lawes, Susan Lee, Sue London, Steve Lynch, Robert MacKintosh, Mark Macrides, Bob Magnusson,

Denise Markonish, Jack Massey, Dale Masten, Edward and Judy Mayer, Talin Megherian, Gracia Melanson, Ana Mendieta, Paul Miyamoto, Don Moore, Galen Murphy, Paul Nestork, Gina Occhiogrosso, Thom and Linda O'Connor, Lecia O'Dell, Maggie Orth, Frank and Martha Lee Owen, Kay Painter, Jeff Paules, Rob Peagler, Bob and Deidre Picciano, Panayiotis Pieredes, Josh Pearson, Gardner Post, J. Morgan Puett, Ann Pugh, Jeff Quinn, David Riebe, Corinna Ripps Schaming, Cheryl Ryder, Virginia Salter, Ryan Salvas, James Scott, Catherine Seidenberg, Linda Shearer, Bill Skiff, Cynthia Slavens, Larry Smallwood, Nancy Stone, Lila Stromberg, Joe Thompson, Nato Thompson, John Udvardy, Mary Wallen, Ken Warriner, Mark Waskow, The Weasels, Jeffrey Wright-Sedam, Al Wunderlich, Gregor Wynnyczuk, Mel Ziegler, Adala Zelman.

Thanks to The Albany County Hall of Records, Albany, NY; Albany Center Galleries, Albany, NY; The Arts Center of the Capital Region, Troy, NY; Artspace, New Haven; CT, Lenore Gray Gallery, Providence, RI; Mary Ryan Gallery, New York, NY; MillerBlock Gallery, Boston, MA; The Nancy Graves Foundation, New York, NY; Pinchbeck Roses, Guilford, CT; Tower Optical Co., Norwalk, CT; and ZieherSmith, New York, NY.

I'd like to thank the entire staff of the Tang for their assistance and good humor in putting together the exhibition, particularly Chris Kobuskie, Nick Warner, Elizabeth Karp, and Torrance Fish. Thanks to Curatorial Assistant Ginny Kollak for her attention to detail and to John Weber for riding it out.

And finally, thank you Ian. Six years ago you said, "let's do this"—and you stayed the course. You helped me to see my work again at a crucial stage in life. Your counsel and friendship mean so much to me. Thank you for your scholarship, vision and courage.

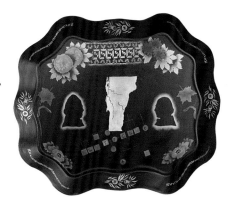

Michael Oatman and
Marge Harding
*Vermont Tole Tray
(Death Tole)*, 2000
Metallic pigments,
metal leaf, varnish
and enamel paint
on found tray
Courtesy of the artist

The exhibition, "A Lifetime of Service and a Mile of Thread", is dedicated to Lori Drinkwater (1963–2000). We became artists together; I miss you.

This catalog is dedicated to my great teacher, mentor, and friend, Alfred DeCredico. Thanks for everything.

—MICHAEL OATMAN

This catalogue accompanies the exhibition

OPENER **9**

MICHAEL OATMAN:

A LIFETIME OF SERVICE AND A MILE OF THREAD

The Frances Young Tang Teaching Museum and Art Gallery at Skidmore College,
Saratoga Springs, New York
June 25–September 11, 2005

The Frances Young Tang Teaching Museum and Art Gallery
Skidmore College
815 North Broadway
Saratoga Springs, New York 12866
T 518 580 8080
F 518 580 5069
www.skidmore.edu/tang

This exhibition and publication are made possible with public funds from the
New York State Council on the Arts, a state agency, The Laurie Tisch Sussman
Foundation, The Overbrook Foundation, and the Friends of the Tang.

© 2006 The Frances Young Tang Teaching Museum and Art Gallery
ISBN 0-9725188-8-6
Library of Congress control number: 2006932013

This page:
Oatman family house during
consruction, 1964
Williston, Vermont

Cover:
Husbandry, 2005 (detail)
Collage on spray painted
paper in two panels
24" x 20' long
Courtesy of the artist

Page 1:
*A Boy's History of the World
in 26 Volumes*, 1983
(detail of comic book rack view)
Twenty-six collages on paper
Each approximately 10 x 7"
Courtesy of the artist

Photographs:
Cover, 2–3, 4, 24, 25, 30, 31, 32, 33, 34, 35,
49–61, 63, 64–82, 92, 95: Arthur Evans
Pages 1: Tim Kness
Pages 8, 9, 14, 20, 38, 39, 44, 46, 48, 85, 88:
Michael Oatman
Page 21: Leif Zurmuhlen
Pages 36, 37: Nicole Keyes
Pages 40–43: Ken Burris
Page 47: Alan Okey

Designed by Bethany Johns
Printed in Germany by Cantz